BARCELONA
City Highlights

teNeues

Imprint

Texts: Yasemin Erdem
Service: Marianne Bongartz, MaBo-Media, Cologne
Translations: Alphagriese Fachübersetzungen, Dusseldorf; Susanne Olbrich (Service)
Editorial management: Hanna Martin
Layout: Katharina Feuer, Anne Dörte Schmidt
Imaging and Pre-press: Jan Hausberg, Martin Herterich

Photo credits: Xavier Babarro, Michelle Galindo und Martin Nicholas Kunz, beside: photo: Xavier Babarro – copyright Antoni Tàpies "Rinzen," 1992–93, Collecció MACBA, Fundació Museu d'Art Contemporanide Barcelona. Donació REPSOL YPF (p. 46 l.), courtesy The Ritz-Carlton Arts Barcelona (pp. 114 t. and 115), courtesy Banys Orientals (p. 117), courtesy Fitness Center Rey Juan Carlos (p. 5 b. r.), courtesy Derby Hotels Collection (p. 128 r.), courtesy Gran Hotel La Florida (p. 137), Pepo Segura – courtesy Fundació Mies van der Rohe (p. 60), © Museu Picasso, Barcelona 2006. Foto: Pepe Herrero, Succession Picasso/VG Bild-Kunst, Bonn 2007 (p. 50), courtesy Museu Marítim Barcelona (p. 48 t. and b. r.), courtesy Hotel Omm (p. 132), Ruben Moreno, courtesy Palau de la Generalitat, Barcelona (pp. 8 t. r., 18 r. and 19), courtesy Vinçon Barcelona (pp. 110–111)
Cover: Xavier Babarro

Content and production: fusion publishing GmbH, Stuttgart . Los Angeles
www.fusion-publishing.com

teNeues Publishing Group

teNeues Verlag GmbH + Co. KG
Am Selder 37
47906 Kempen, Germany
Tel.: 0049 / (0)2152 / 916 0
Fax: 0049 / (0)2152 / 916 111

teNeues Publishing Company
16 West 22nd Street
New York, NY 10010, USA
Tel.: 001-212-627-9090
Fax: 001-212-627-9511

teNeues Publishing UK Ltd.
P.O. Box 402
West Byfleet, KT14 7ZF
Great Britain
Tel.: 0044-1932-403509
Fax: 0044-1932-403514

teNeues France S.A.R.L.
93, rue Bannier
45000 Orléans, France
Tel.: 0033-2-38541071
Fax: 0033-2-38625340

Press department: arehn@teneues.de
Tel.: 0049 / (0)2152 / 916 202

www.teneues.com

© 2007 teNeues Verlag GmbH & Co. KG, Kempen

All rights reserved.
All contents are copyright. No part of this publication may be reproduced, stored or introduced into a retrieval system, or transmitted, in any form or by any means (electronic, mechanical, photocopying, recording, or otherwise), without the prior written permission of the publisher.

The information and facts in this publication have been researched and verified with utmost accuracy. However, the publisher acknowledges that the information may have changed when this work was published and therefore the publisher assumes no liability for the correctness of the information. The editor and publisher make no warranties with respect to the accuracy or completeness of the content of this work, including, without limitation, the "Service" section.

Copy deadline: 1 February 2007

All vernacular information is given in Catalan.

Bibliographic information published by Die Deutsche Bibliothek. Die Deutsche Bibliothek lists this publication in the Deutsche Nationalbibliografie; detailed bibliographic data is available in the Internet at http://dnb.ddb.de.

ISBN 978-3-8327-9192-6

Printed in Italy

Right page:
House in Gràcia

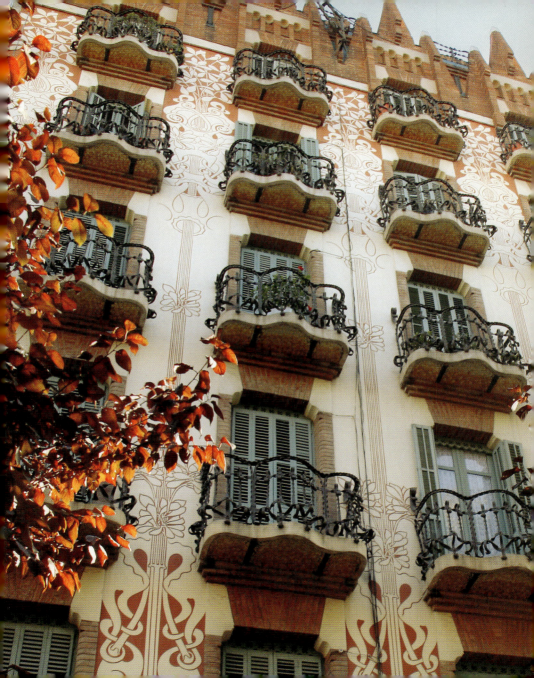

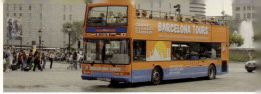

Introduction . 6

Sightseeing

Palau de la Generalitat. 18
Plaça Reial. 20
Les Rambles. 22
Casa Batlló . 24
Casa Milà (La Pedrera) 26
Sagrada Família 28
Park Güell . 32
Monestir de Pedralbes 34
Anella Olímpica (Olympic Ring) 36
Torre Agbar 38
Port Olímpic. 40

Culture:
Museums, Galleries, Theaters, Cinemas

Gran Teatre del Liceu 44
Museu d'Art Contemporani – MACBA . . 46
Museu Marítim 48

Museu Picasso 50
Palau de la Música Catalana 52
Fundació Antoni Tàpies 54
Fundació Joan Miró. 56
Museu Nacional d'Art de Catalunya –
 MNAC. 58
Pavelló Mies van der Rohe. 60

Restaurants, Cafés, Bars, Clubs

Agua . 64
Bestial . 66
Boadas Cocktail Bar. 68
Café de L'Acadèmia 70
Café Schilling. 72
Carpe Diem Lounge Club & Restaurant . 74
CheeseMe. 76
Comerç 24. 78
Cuines Santa Caterina 80
Els Quatre Gats. 82
Rita Blue . 84
Torre D'Alta Mar 86

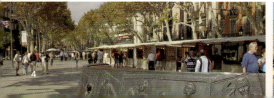
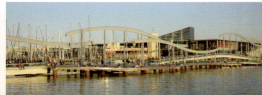

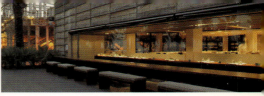

Casa Calvet 88
Taktika Berri 90
Ot . 92

Shopping

Caelum . 96
Xocoa . 98
Iguapop Shop 100
Mercat de la Boqueria 102
Vila Viniteca 104
Casa del Llibre 106
Passeig de Gràcia 108
Vinçon . 110

Hotels

Hotel Arts Barcelona 114
Banys Orientals 116
Casa Camper Barcelona 118
H1898 . 120
Neri Hotel & Restaurante 124

Axel Hotel Barcelona 126
Granados 83 128
Market Hotel 130
Hotel Omm 132
Pulitzer . 134
Gran Hotel La Florida 136

What else?

L'Aquàrium de Barcelona 140
Harbor Tour in the Golondrinas 142
Jardí Botànic de Barcelona 144
Transbordador Aeri del Port 146
Municipal Beaches:
 Platja de la Barceloneta, Platja Nova
 Icària, Platja del Bogatell 148

Service

Useful Tips & Addresses 150
Map . 158

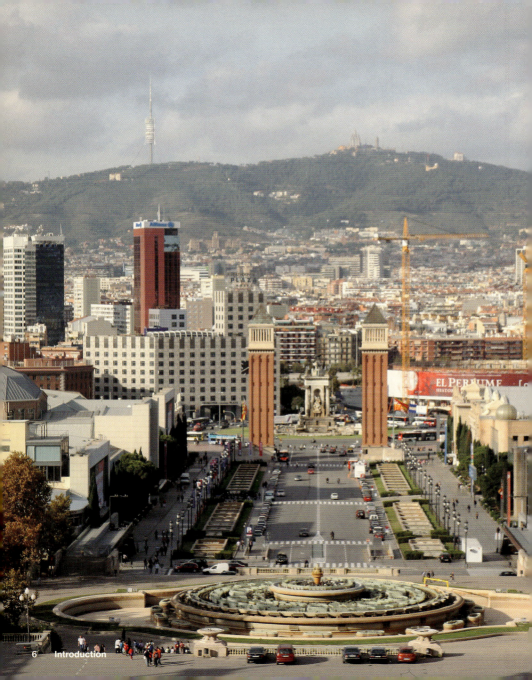

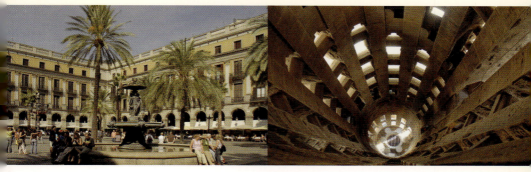

Left page: Font Màgica and Plaça d'Espanya in the background
Right page: Plaça Reial, interior view of the Sagrada Família

A City Like a Vacation

Do you prefer the ocean or the mountains? Either way, you will find both in Barcelona. The picturesque setting of this city is reminiscent of an open-air museum. You can easily get a first quick overview of the city with its Mediterranean flair, sensual temperament, and sunny weather. An especially charming aspect: Despite the variety of attractions, Barcelona doesn't rush and impose the feeling that you are missing out on something. You can determine your very own tempo here. Even if you just sit in a café and people-watch: You will feel the love of life that the locals have and their contagious lightheartedness. There is often a direct view of the ocean and sandy beaches invite you to sunbathe. Barcelona means vacation. And if you have a desire for culture: The splendid buildings of *Modernisme*—the Catalonian art nouveau of architects Antoni Gaudí, Josep Puig i Cadafalch, and Lluís Domènech i Montaner—are a feast for the eyes, and not just for confirmed fans of architecture. They are part of the world's cultural heritage. The 1929 World Exhibition defined Barcelona, just like the 1992 Olympic Games. Fantastic temples of art and music compete for the visitor's favor. In terms of design and shopping, Barcelona is one of the most innovative cities in the world. According to the legend, you will return to Barcelona time and again if you drink from the Font de Canaletes fountain on the Rambles boulevard. But this is hardly necessary because you will fall in love with the city anyway.

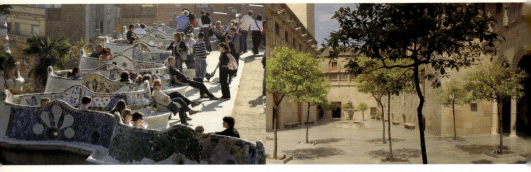

Left page: Park Güell, courtyard of the Palau de la Generalitat
Right page: Start of the Rambles

Une ville synonyme de vacances

Etes-vous plutôt mer ou plutôt montagne ? Peu importe, vous trouverez les deux à Barcelone. Son cadre pittoresque évoque un musée à ciel ouvert. Vous prendrez vite le pouls de cette ville au style méditerranéen, au tempérament sensuel et au climat ensoleillé. Ce qui séduit particulièrement, c'est que, malgré la variété de ses attraits, Barcelone ne se presse pas et ne vous donne pas l'impression de manquer quoi que ce soit. Ici, vous décidez de votre propre tempo. Même si vous vous asseyez simplement dans un café et regardez les passants, vous ressentirez la joie de vivre et l'enthousiasme contagieux de ses habitants. Vous avez souvent une vue directe sur la mer, et les plages de sable vous invitent à bronzer. Barcelone est synonyme de vacances. Et si vous avez soif de culture, les magnifiques bâtiments du *Modernisme* – l'art nouveau catalan des architectes Antoni Gaudí, Josep Puig i Cadafalch et Lluís Domènech i Montaner – sont un régal pour les yeux, et pas seulement pour les férus d'architecture. Ils font partie du patrimoine mondial. L'Exposition Universelle de 1929 a façonné Barcelone, tout comme les Jeux Olympiques de 1992. De fabuleux temples de l'art et de la musique se disputent les faveurs des visiteurs. En matière de design et de shopping, Barcelone est une des villes les plus innovantes au monde. D'après la légende, si vous avez bu une fois l'eau de la fontaine Font de Canaletes, sur le boulevard piétonnier des Rambles, vous reviendrez toujours à Barcelone. Mais c'est à peine nécessaire, car vous tomberez amoureux de la ville quoi qu'il arrive.

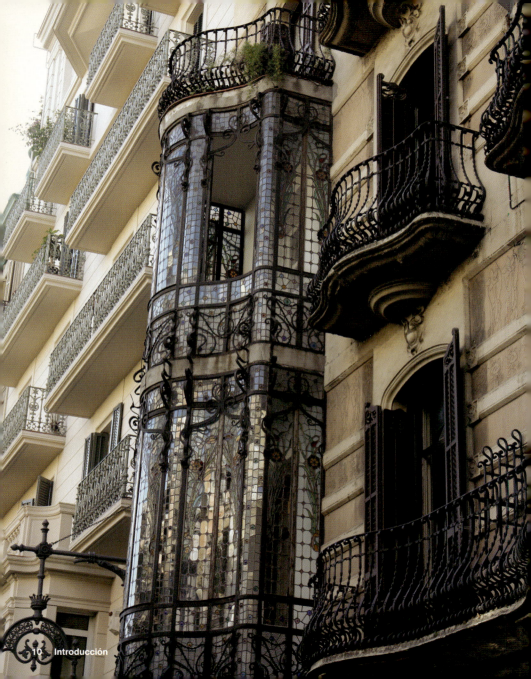

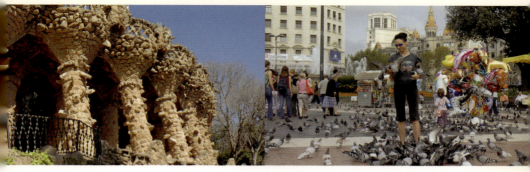

Left page: Apartment house in Gràcia
Right page: Park Güell, Plaça de Catalunya

Una ciudad siempre de vacaciones

¿Prefiere el mar o la montaña? La verdad es que no importa: en Barcelona encontrará ambas. La ciudad está situada en un enclave pintoresco que recuerda a un museo a cielo abierto. Su espíritu se reconoce con la primera mirada, su sabor es mediterráneo, es sensual y soleada. Aún sin concentrarnos en sus atracciones, nunca tendremos la impresión de estar pasando algo por alto, lo que proporciona una sensación muy agradable. Podemos marcarnos nuestro propio paso. Sentados en un café y estudiando las caras de nuestro entorno, percibimos ganas de vivir y una contagiosa despreocupación. A menudo, miramos hacia el mar, hacia las playas que nos invitan a darnos un baño de sol. Barcelona son vacaciones. Desde el punto de vista cultural, los magníficos edificios modernistas, creados con estilo modernista catalán de los arquitectos Antoni Gaudí, Josep Puig i Cadafalch y Lluís Domènech i Montaner, son un placer para la vista, no solamente para los fanáticos de la arquitectura, ya que son parte del patrimonio cultural de la humanidad. La Exposición Mundial del año 1929 ha marcado Barcelona, al igual que los Juegos Olímpicos de 1992, dejando fantásticos templos culturales y musicales, que compiten entre sí en atractivo y encanto. En cuanto a moda y diseño, Barcelona también pertenece al grupo de las metrópolis más innovadoras del mundo. La leyenda cuenta que si bebemos de la Font de Canaletes en el paseo de las Ramblas, siempre volveremos a Barcelona. Pero esto apenas es necesario … en cualquier caso, quedaremos prendidos de la ciudad.

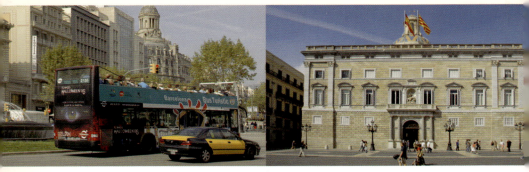

Left page: Tourist bus on Passeig de Gràcia, exterior view of the Palau de la Generalitat
Right page: Church Sagrat Cor

Una città come in vacanza

Mare o montagna? È lo stesso, a Barcellona entrambe le opzioni sono disponibili. Situata in posizione pittoresca, la città ricorda un museo a cielo aperto. Sensuale e assolata, già dalla prima occhiata si percepisce la sua anima mediterranea. Particolarmente piacevole il fatto che, anche se c'è tantissimo da vedere, Barcellona non dà l'affanno, non si ha mai l'impressione di tralasciare qualcosa. Possiamo decidere il nostro ritmo e il nostro passo, sederci di tanto in tanto in un bar e osservare le persone, avvertendo la loro voglia di vivere, la loro contagiosa spensieratezza. Spesso ci sorprendiamo a guardare il mare e le spiagge sabbiose che ci invitano a prendere il sole. Barcellona è vacanza. Per chi sia spinto da interessi culturali, i magnifici edifici del *modernismo* – l'Art Noveau catalana degli architetti Antoni Gaudí, Josep Puig i Cadafalch e Lluís Domènech i Montaner – sono un piacere per gli occhi, e non solo per i fan più incalliti dell'architettura, essendo parte del patrimonio dell'umanità. L'Esposizione Mondiale del 1929 ha lasciato il segno sulla città, proprio come i Giochi Olimpici del 1992. Fantastici templi artistici e musicali si disputano il nostro favore. Infine, anche in fatto di moda e design, Barcellona è una delle metropoli più innovative al mondo. La leggenda racconta che chi beve alla Font de Canaletes, sulle Ramblas, tornerà ancora a Barcellona ... Ma in ogni caso non sfuggiremo al suo fascino, non potremo fare a meno di innamorarci di questa città.

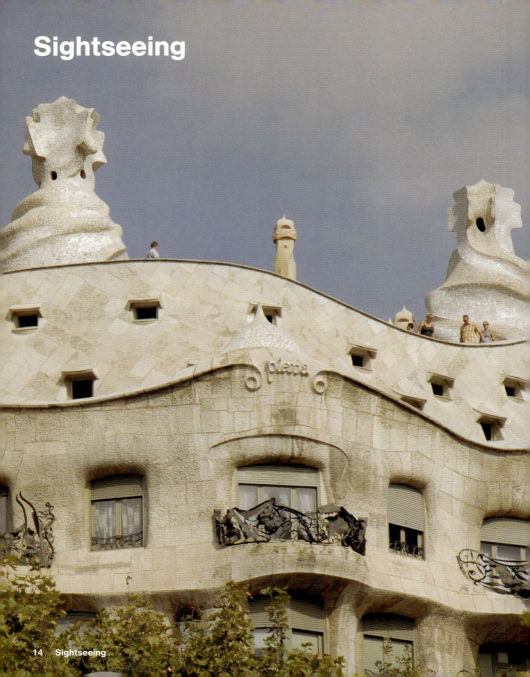

Sightseeing

Despite its size, Barcelona is still easy to figure out. You can get your first impression of it on a walk on the Rambles. The medieval quarter of Barri Gòtic is important, too, and Montjuïc—Barcelona's local mountain—is also worth an excursion. Eixample has showpieces of *Modernism*, including many by the legendary architect Antoni Gaudí. An absolute must: the Sagrada Família church.

Même si c'est une grande ville, il est facile de se repérer à Barcelone. Vous pouvez vous faire une première impression en vous promenant sur les Rambles. Impossible de faire l'impasse sur le quartier médiéval, le Barri Gòtic, et Montjuïc – la colline de Barcelone – mérite une excursion. L'Eixample comporte des chefs d'œuvre du *modernisme*, dont on doit un grand nombre au légendaire architecte Antoni Gaudí. Le must absolu : l'église de la Sagrada Família.

Orientarse en Barcelona es fácil, a pesar de su extensión. Una buena idea para echar un primer vistazo es dar un paseo por las Ramblas o por el Barrio Gótico, o también realizar una excursión de un día por el Montjuïc. En el Eixample se encuentran las obras más representativas del modernismo, incluidas muchas de las del legendario Antoni Gaudí. Visitar la Iglesia de la Sagrada Família resulta imprescindible.

Barcellona è agevolmente percorribile, nonostante le sue dimensioni. Una prima occhiata si può dare passeggiando sulle Ramblas o per il quartiere medievale del Barri Gòtic; anche il Montjuïc, che domina la città, merita una gita giornaliera. Nell'Eixample si trovano delle vere chicche del *modernismo*, comprese molte opere del leggendario architetto Antoni Gaudí. Un "must" assoluto: la chiesa della Sagrada Família.

Left page: Casa Milà (La Pedrera)
Right page: Left Plaça d'Espanya, right Torre Calatrava communication tower

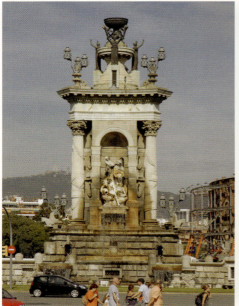
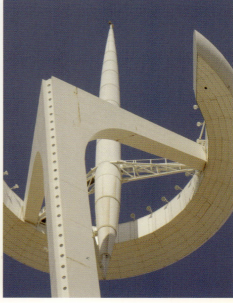

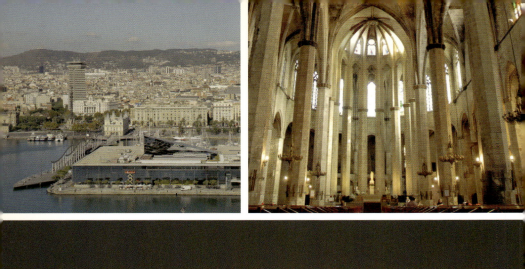
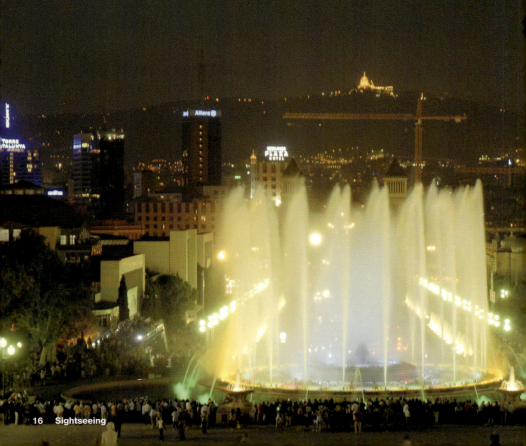

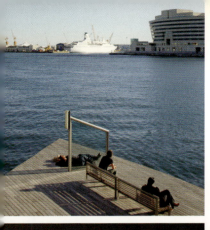

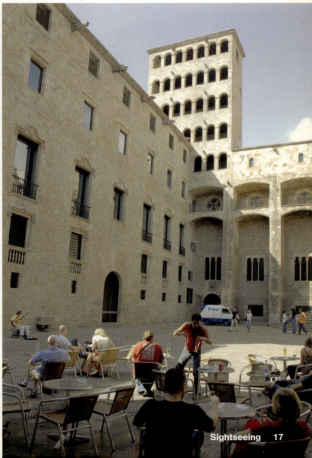

Left page: Top left harbor with Maremàgnum shopping center, top right church Santa María del Mar, bottom Font Màgica
Right page: Top harbor with World Trade Center, bottom Plaça del Rei

Palau de la Generalitat

Plaça de Sant Jaume, s/n
08002 Barcelona
Barri Gòtic, Ciutat Vella
Phone: +34 / 934 02 46 00
www.gencat.es

Opening hours: 2nd and 4th Sun of each month
Admission: Free
Special notes: Guides tours in English, Spanish and Catalan
Public transportation: Metro Jaume I
Map: No. 43

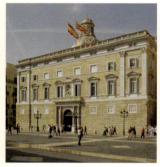
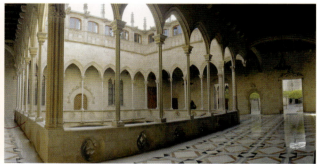

The palace with its Renaissance façade, one of Barcelona's most important historic structures, was built around a Gothic core between 1403 and 1630. The optical highlight is the Gothic inner court of 1425. Palau de la Generalitat is now the seat of the government of the Autonomous Community of Catalonia.

Ce palais à la façade Renaissance, l'un des plus importants monuments historiques de Barcelone, a été construit entre 1403 et 1630 autour d'un cœur gothique. A ne pas manquer : la cour intérieure gothique datant de 1425. Le Palau de la Generalitat est maintenant le siège du gouvernement autonome catalan.

Con su fachada renacentista, el Palau es uno de los edificios históricos más importantes de Barcelona. Fue construido entre 1403 y 1630 en torno a un núcleo gótico. El punto más interesante visualmente es el patio interior, también gótico, del año 1425. Hoy, el Palau de la Generalitat es la sede del gobierno autonómico catalán.

Costruito tra il 1403 e il 1630 attorno all'originale nucleo gotico, il Palau, con la sua facciata rinascimentale, è tra i più importanti edifici storici di Barcellona. Il punto di maggior interesse estetico è il cortile interno, sempre in stile gotico, che risale al 1425. Oggi il complesso è sede del governo regionale autonomo catalano.

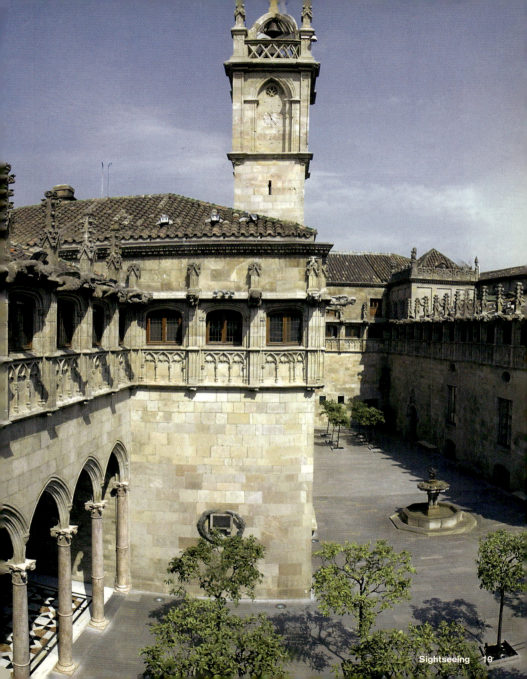

Plaça Reial

Plaça Reial
08002 Barcelona
Ciutat Vella
www.lareial.com

Public transportation: Metro Liceu
Map: No. 48

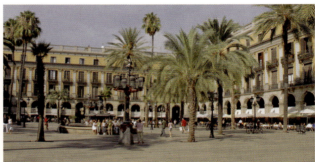

One of the city's most enchanting plazas: Restaurants and bars in wide arcade halls, tall date palms, and the fountain of the Three Graces at the center of the plaza form a beautiful setting. The façades of the Royal Plaza are classical, but the lanterns are modernistic — they are the work of Antoni Gaudí.

Une des plus agréables places de la ville : les restaurants et les bars sous de grandes arcades, les hauts dattiers et la fontaine des Trois Grâces au centre de la place composent un cadre enchanteur. Les façades de cette place royale sont classiques, mais les réverbères — l'œuvre d'Antoni Gaudí – sont modernistes.

Es una de las plazas con más encanto de la ciudad: encontramos restaurantes y bares en amplias arcadas peatonales, altas palmeras y el Pozo de las Tres Gracias en el centro de la plaza: el conjunto crea un escenario magnífico. Las fachadas que rodean la plaza son neoclásicas, las farolas son modernistas, obra de Antoni Gaudí.

È una delle piazze più incantevoli della città. Ristoranti e bar in ampie gallerie pedonali, altissime palme da dattero e il Pozzo delle Tre Grazie al centro contribuiscono a creare uno splendido scenario. Le facciate che circondano la Piazza Reale sono neoclassiche, mentre le lanterne sono in stile modernista, opera di Antoni Gaudí.

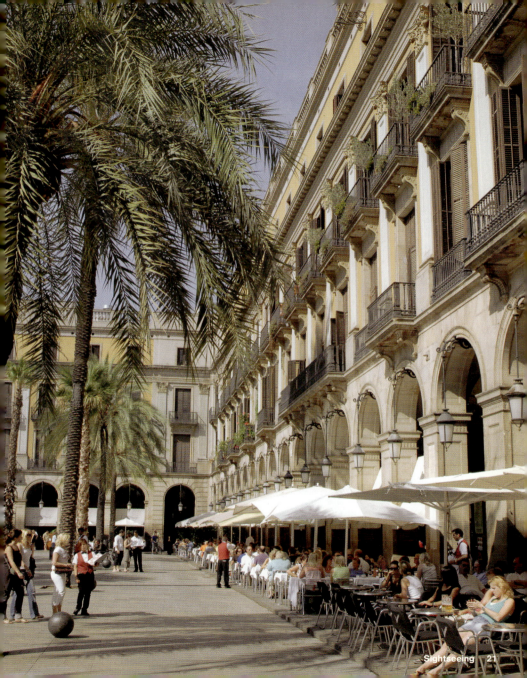

Les Rambles

08002 Barcelona
Ciutat Vella

Special notes: A 1.2 km-long pedestrian mall connecting the Christopher Columbus monument at the harbor and Plaça de Catalunya
Public transportation: Metro Drassanes, Liceu, Catalunya
Map: No. 32

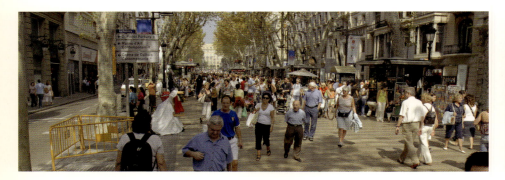

The Rambles are more than just an upscale shopping zone: The street artists and musicians turn the boulevard, built at the end of the 18th century, into a big cabaret theater. The famous Café de l'Opéra is next to the flower stalls and markets here. Many houses also have the beautiful façades of Catalan art nouveau.

Les Rambles sont plus qu'un superbe boulevard piétonnier : les artistes de rue et les musiciens font de ce boulevard, construit à la fin du XVIIIe siècle, un cabaret à ciel ouvert. On y trouve le fameux Café de l'Opéra à proximité des stands des fleuristes et des marchés. On peut aussi y admirer de nombreuses maisons aux façades art nouveau.

Las Ramblas son algo más que un simple paseo: artistas y músicos callejeros transforman la avenida, originaria de finales del siglo XVIII, en un escenario multicolor. Además de puestos de flores y mercadillos, encontramos el famoso Café de l'Opéra. Muchos de los edificios presentan bellas fachadas en el estilo modernista catalán.

Le Ramblas sono qualcosa di più che una passeggiata: artisti e musicisti di strada trasformano il viale, risalente alla fine del secolo XVIII, in un lungo palcoscenico all'aperto. Oltre ai mercatini e alle bancarelle dei fiorai, vi si trova anche il famoso Café de l'Opéra. Molti dei palazzi presentano magnifiche facciate moderniste.

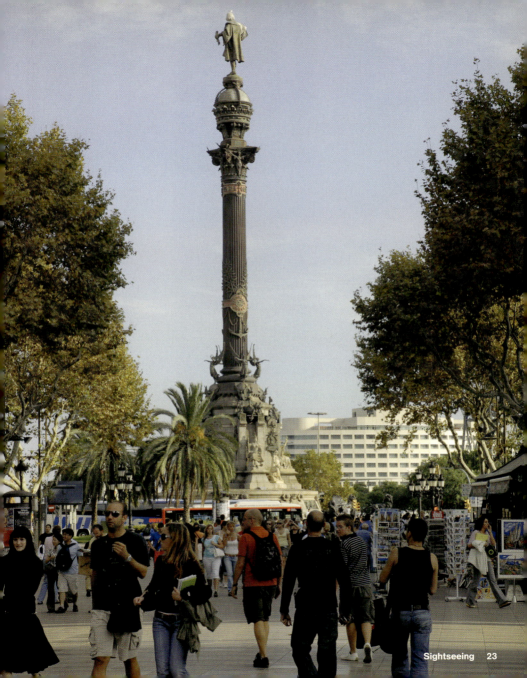

Casa Batlló

Passeig de Gràcia, 43
08007 Barcelona
Eixample
Phone: +34 / 932 16 03 06
www.casabatllo.cat

Opening hours: Daily 9 am to 8 pm
Admission: Main story and the roof € 16.50, groups (20+ people) receive 20 % discount
Public transportation: Metro Passeig de Gràcia
Map: No. 12

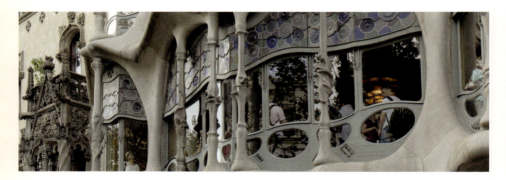

The dragon from the legend of St. George, the patron saint of Catalonia, inspired Antoni Gaudí when redesigning this residential house. The balcony balustrades look like bones, and the glazed tiles resemble the scales of the mythical creature. The ceramic tiles shine in radiant hues and a colorful tower crowns the building.

Antoni Gaudí a été inspiré par les dragons de la légende de St Georges, le saint patron de la Catalogne, quand il a restauré cette résidence. Les balustrades du balcon évoquent des os et les tuiles vernies, les écailles d'une créature mythique. Les tuiles de céramique brillent de couleurs chatoyantes et une tour colorée couronne le bâtiment.

Para el diseño de esta casa urbana, Antoni Gaudí se dejó inspirar por el dragón de la leyenda de San Jorge, Santo patrono de Cataluña. Las barandillas recuerdan a los huesos del dragón y los azulejos a las escamas de este ser fabuloso y mítico. Los azulejos brillan en vivos colores y la construcción está coronada por una torre multicolor.

Per la ristrutturazione di questo edificio residenziale, Antoni Gaudí si ispirò al drago della leggenda di San Giorgio, santo patrono della Catalogna. Le ringhiere e le mattonelle ricordano rispettivamente le ossa e le scaglie del mitico animale. Le ceramiche brillano in colori vivaci, una variopinta torre fa da corona al tutto.

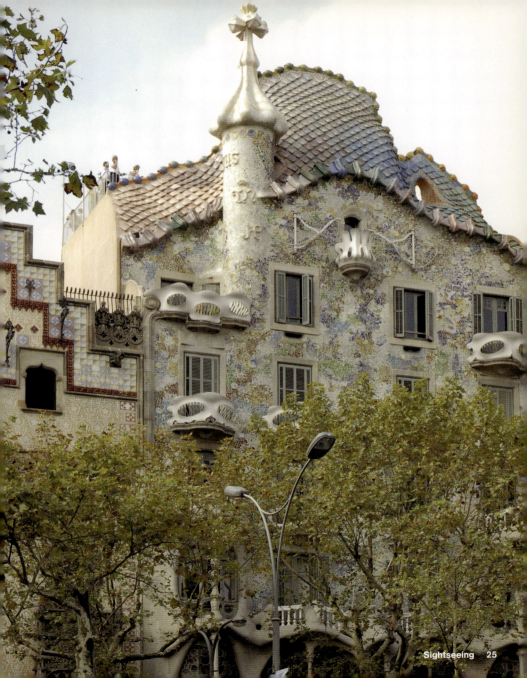

Casa Milà (La Pedrera)

Passeig de Gràcia, 92
08007 Barcelona
Eixample
Phone: +34 / 934 84 59 95
www.casamila.com

Opening hours: Daily 10 am to 8 pm
Admission: € 8
Special note: UNESCO World Heritage Site
Public transportation: Metro Diagonal
Map: No. 16
Editor's tip: In summer, the rooftop terrace is open until midnight. Visit the exhibition on Gaudí and his works and listen to live music.

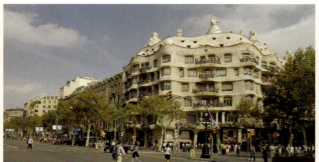

The façade of the apartment house built between 1906 and 1910 by Antoni Gaudí looks like an ocean wave. There are no supporting walls here. Every room has a different layout, and the separating walls in the various apartments can be adjusted individually. Casa Milà has been included in the World Cultural Heritage of UNESCO since 1984.

La façade de cet immeuble construit entre 1906 et 1910 par Antoni Gaudí ressemble à une vague. Ici, pas de mur porteur. Chaque pièce est configurée différemment et les murs de séparation dans les différents appartements peuvent être déplacés individuellement. La Casa Milà est classée au patrimoine mondial de l'UNESCO depuis 1984.

La fachada del edificio residencial, construido por Antoni Gaudí entre 1906 y 1910, recuerda a las olas del mar. No existe un muro principal, todos los espacios tienen contornos diferentes, y los tabiques de los cuartos pueden ajustarse individualmente. Desde 1984 la Casa Milà pertenece al patrimonio mundial de la UNESCO.

La facciata dell'edificio, costruito tra il 1906 e il 1910 da Antoni Gaudí, ricorda le onde marine. Non esiste muro portante, tutti i vani hanno pianta diversa, le pareti che separano le stanze sono regolabili individualmente. Dal 1984 Casa Milà appartiene al patrimonio dell'umanità tutelato dall'UNESCO.

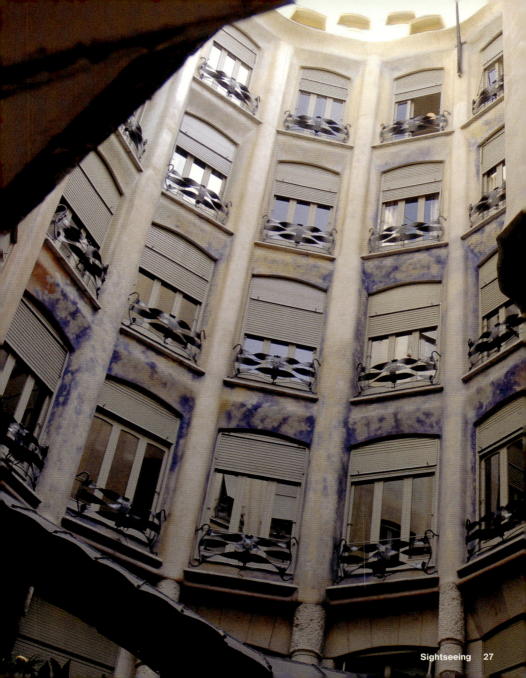

Sagrada Família

Carrer de Mallorca, 401
08013 Barcelona
Eixample
Phone: +34 / 932 07 30 31
www.sagradafamilia.org

Opening hours: Oct–March 9 am to 6 pm, April–Sept 9 am to 8 pm
Admission: € 8
Special note: There is a museum on the building history inside the cathedral.
Public transportation: Metro Sagrada Família
Map: No. 52
Editor's tip: At night you can enjoy the a panoramic view of Barcelona's landmark from the bar "Mirablau" (Plaça Dr. Andreu).

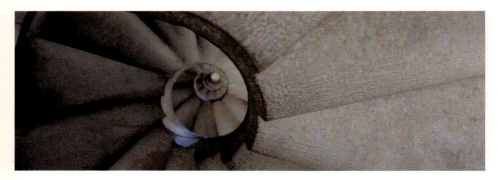

The building of Antoni Gaudí's major work and symbol of Barcelona began in 1882 and is still incomplete to this day. The twelve towers of the church portray the apostles, four additional towers are dedicated to the evangelists and two to the Virgin Mary. The three façades represent the life of Christ. Gaudí himself was only able to complete the eastern façade.

La construction de cette église, chef d'œuvre d'Antoni Gaudí et symbole de Barcelone, a commencé en 1882 et n'est toujours pas achevée à ce jour. Ses douze flèches représentent les douze apôtres. Quatre flèches supplémentaires sont consacrées aux évangélistes, et deux à la Vierge Marie. Les trois façades représentent la vie du Christ. Gaudí lui-même n'a pu achever que la façade orientale.

Las doce torres de la Iglesia, cuya construcción comenzó en 1882 y aún está por terminar, obra maestra de Gaudí y emblema de Barcelona, personifican a los Apóstoles, cuatro torres adicionales a los Evangelistas, y otras dos más están dedicadas a la Virgen María. De las tres fachadas sobre la vida de Jesús, tan sólo el lado Este pudo ser completado por el propio Gaudí.

Le dodici torri della costruzione, iniziata nel 1882 e non ancora terminata – capolavoro di Gaudí e simbolo della città – personificano gli Apostoli, quattro altre torri ricordano gli Evangelisti, due sono dedicate a Maria. Delle tre facciate sulla vita di Cristo, Gaudí riuscì a terminare personalmente solo il lato est.

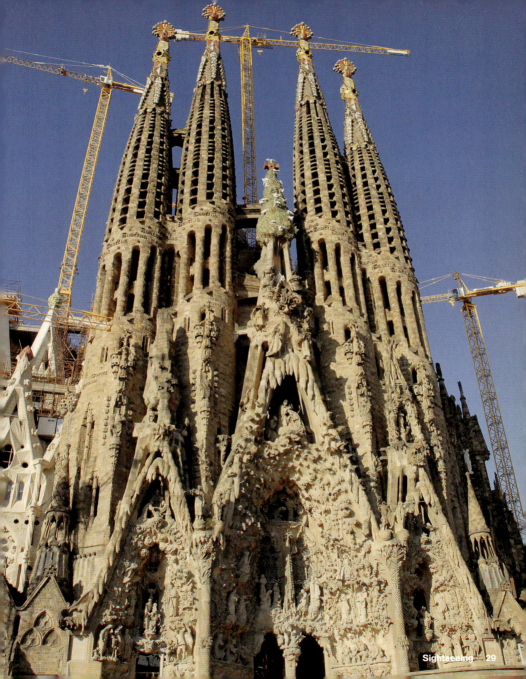

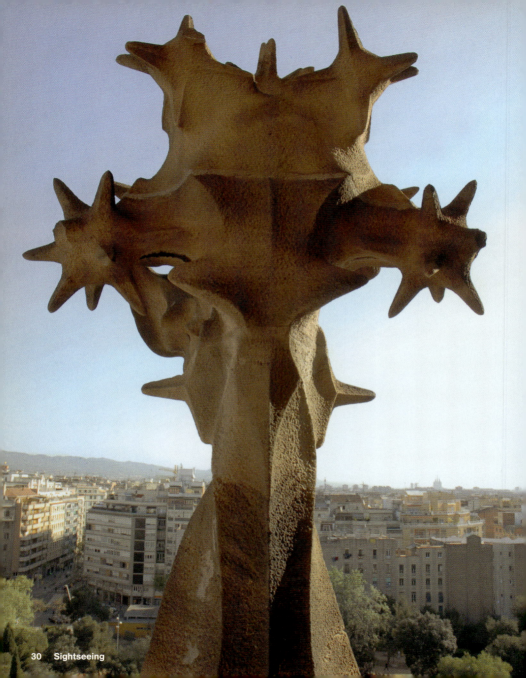

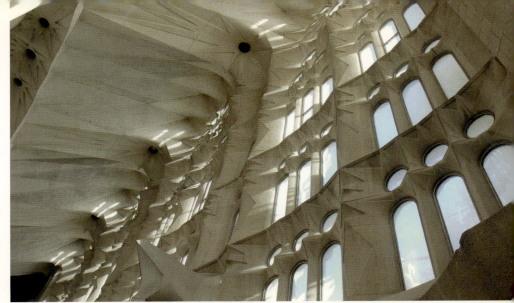

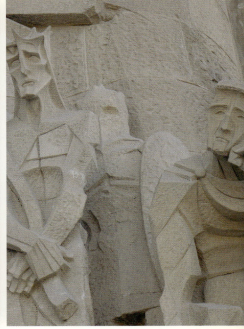

Sightseeing

Park Güell

Gràcia
Phone: +34 / 934 13 24 00

Opening hours: Daily 10 am to 8 pm
Admission: Free
Special notes: UNESCO World Heritage Site, Gaudí museum at the main entrance
Public transportation: Metro Lesseps
Map: No. 45

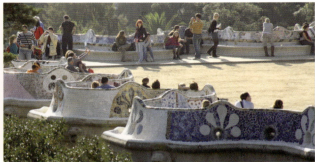

From 1900 to 1914, Eusebi Güell had this park built by Antoni Gaudí: The result was a playful dream landscape with serpentine paths and luxuriant vegetation. The lookout terrace on the columned hall offers a fantastic view of the city and the ocean. The park has been part of UNESCO's World Cultural Heritage since 1984.

Eusebi Güell confia la construction de ce parc à Antoni Gaudí entre 1900 et 1914. Le résultat : un paysage onirique et ludique aux sentiers serpentant au milieu d'une végétation luxuriante. De la terrasse qui surplombe les colonnes de la galerie, on a une vue fantastique sur la ville et sur la mer. Le parc est classé au patrimoine mondial de l'UNESCO depuis 1984.

Entre 1900 y 1914, Eusebi Güell mandó construir este jardín público a Antoni Gaudí. El resultado: un paisaje de ensueño, con caminos serpenteantes y abundante vegetación. El mirador ofrece una maravillosa vista de la ciudad y del mar. Este parque también fue declarado patrimonio mundial por la UNESCO.

Eusebi Güell incaricò Gaudí di progettare questo parco, realizzato tra il 1900 e il 1914: il risultato fu uno paesaggio da sogno, con sentieri serpeggianti e vegetazione rigogliosa. Dalla terrazza panoramica sopra il colonnato si gode una fantastica vista sulla città e sul mare. Dal 1984 il parco appartiene al patrimonio dell'umanità dell'UNESCO.

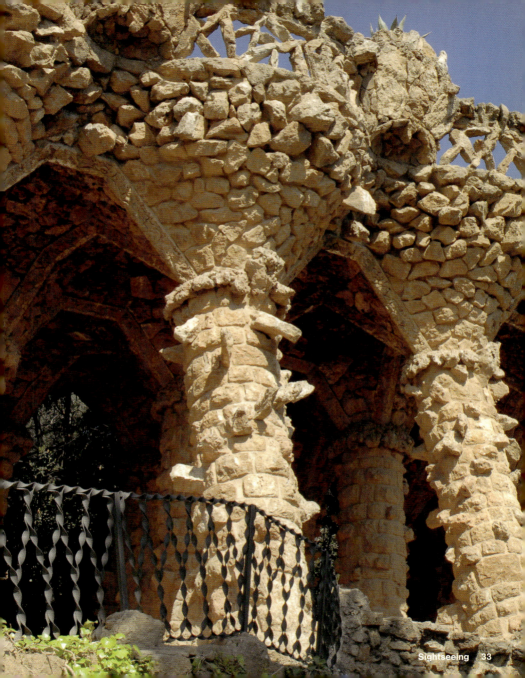

Monestir de Pedralbes

Baixada del Monestir
08034 Barcelona
Les Corts
Phone: +34 / 932 56 21 22
www.museuhistoria.bcn.cat

Opening hours: April–Sept Tue–Sat 10 am to 5 pm, Oct–March Tue–Sat to 2 pm, all year round Sun and legal holidays 10 am to 3 pm
Admission: € 5, first Sun of each month free
Public transportation: Bus Monestir de Pedralbes
Map: No. 35

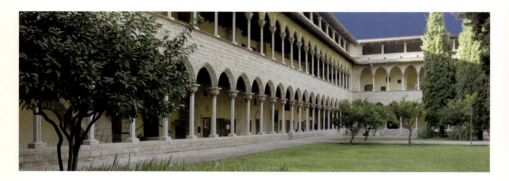

The order of the nuns of St. Clare stayed in this convent, which was founded in 1326, until 1969. The convent church and the convent itself are stylistically correct examples of Catalan Gothic. The three-story cloisters are especially beautiful. The calm and harmonious ensemble is located in a higher part of Barcelona, above the noise of the big city.

Jusqu'en 1969, les sœurs de l'ordre de Ste Claire occupaient ce couvent fondé en 1326. L'église et le couvent lui-même sont de parfaites illustrations du gothique catalan. Les cloîtres sur trois niveaux sont particulièrement beaux. Cet ensemble calme et harmonieux se situe sur les hauteurs de Barcelone, à l'écart du bruit de la grande ville.

Este monasterio, fundado en 1326, hospedó a la Orden de las Clarisas hasta el año 1969. De la iglesia y el monasterio, ejemplos del más antiguo estilo gótico catalán, admiramos especialmente el claustro de tres plantas. El tranquilo y armonioso conjunto está ubicado en la parte más alta de la ciudad, alejado de los ruidos de la metrópoli.

Fondato nel 1326, il monastero ospitò l'Ordine delle Clarisse fino al 1969. La chiesa e il convento sono pregevoli esempi di stile gotico catalano; particolarmente notevole il chiostro a tre piani. Il tranquillo e armonioso complesso è situato nella parte alta della città, lontano dai rumori del centro.

Anella Olímpica (Olympic Ring)

Passeig Olímpic, 5–7
08038 Barcelona
Sants-Montjuïc
Phone: +34 / 934 26 20 89
www.bsmsa.es

Public transportation: Bus Anella Olímpica, Metro Espanya (from there a 15 mins walk)
Map: No. 2

The Olympic Ring is a collection of competition venues for the 1992 Olympic Summer Games. Among the main attractions are the extensively renovated Estadi Olímpic de Montjuïc stadium built for the 1929 World Exhibition, as well as the communication tower of Santiago Calatrava. But the view of the city is also superb.

L'Anneau Olympique est un ensemble de sites sportifs construits pour les Jeux Olympiques d'été de 1992. Parmi ses principales attractions, on trouve le Stade olympique de Montjuïc, construit pour l'Exposition universelle de 1929 et totalement rénové depuis, ainsi que la tour de Santiago Calatrava. Et on y a aussi une magnifique vue sur la ville.

En este conjunto se celebró lugar la mayoría de las competiciones de los Juegos Olímpicos de 1992. Entre las principales atracciones, se encuentra el Estadi Olímpic de Montjuïc, construido para la Exposición de 1929 y luego renovado por completo, y la Torre Telefónica, de Santiago Calatrava. Y sin embargo, todo ello no consigue superar la excepcional vista a la ciudad.

L'Anello comprende le sedi delle competizioni dei Giochi Olimpici del 1992. Tra gli impianti più interessanti troviamo l'Estadi Olímpic de Montjuïc, costruito nel 1929 per l'Esposizione Mondiale e in seguito interamente ristrutturato, e la Torre telefonica, opera di Santiago Calatrava. Ma lo spettacolo migliore è la vista sulla città.

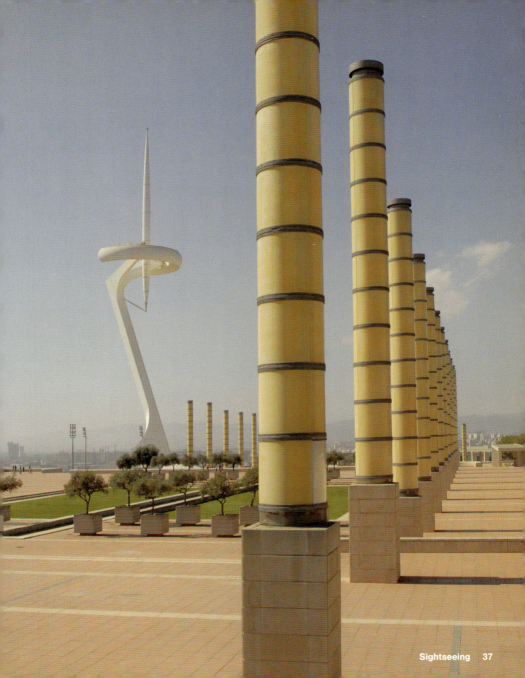

Torre Agbar

Plaça de les Glòries Catalanes / Avinguda Diagonal, 211
08018 Barcelona
Sant Martí
www.torreagbar.com

Special note: No guided tours
Public transportation: Metro Glòries
Map: No. 54

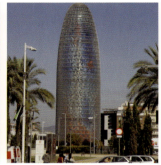

The darker it gets, the more glaring the glow from the glass-aluminum façade of Torre Agbar at the center of Barcelona's skyline becomes. Each of the 4,500 windows has a different color. The inspiration for the 465-ft tall tower constructed by Jean Nouvel were the rounded cliffs of the sandstone Montserrat mountains, the symbol for Catalonia.

Plus il fait sombre, plus la façade d'aluminium et de verre de la Torre Agbar resplendit au centre de la silhouette de Barcelone. Chacune des 4 500 fenêtres est d'une couleur différente. Pour la construction de cette tour de 142 m de haut, l'architecte Jean Nouvel s'est inspiré des falaises de grès des montagnes de Montserrat, le symbole de la Catalogne.

Cuanto más anochece, más luminosa resalta, en el perfil de la ciudad, la fachada en vidrio y aluminio de la Torre Agbar, con sus 4 500 ventanas, cada una de un color distinto. La inspiración para la torre, de una altura de 142 m y proyectada por Jean Nouvel, fueron las piedras redondas de Montserrat, el emblema de Cataluña.

All'imbrunire si staglia luminosa sulla skyline di Barcellona la facciata in vetro e alluminio della Torre Agbar, con le sue 4 500 finestre, ciascuna di un diverso colore. La fonte d'ispirazione dell'architetto Jean Nouvel per il progetto della torre, alta 142 m, furono le rocce arrotondate del massiccio montuoso di Montserrat, simbolo della Catalogna.

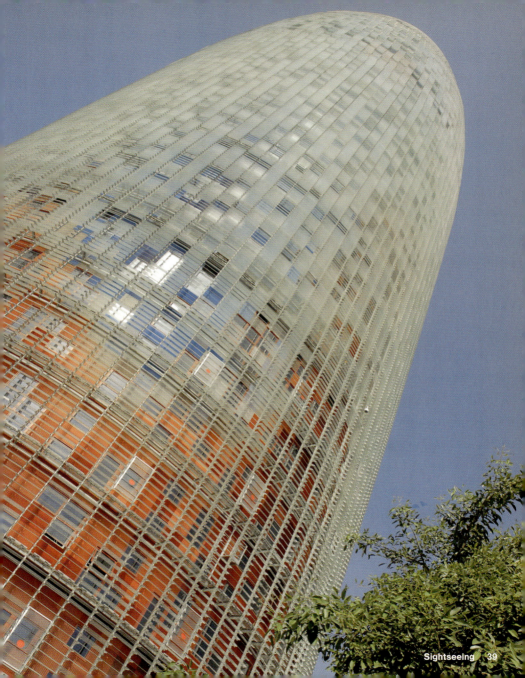

Port Olímpic

Vila Olímpica

Public transportation: Metro Ciutadella Vila Olímpica
Map: No. 49

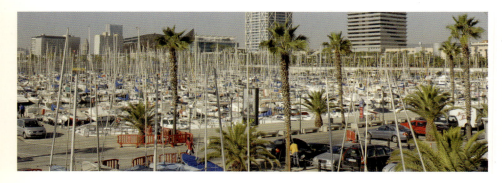

Situated on a wide promenade, this yacht harbor offers many sights: glittering yachts and post-modern architecture, vacationers and locals, beautiful people, the shrill crowd, and the night owls. The Port Olímpic—redesigned for the 1992 Olympic Games—also offers many restaurants with a view of the ocean.

Situé sur une vaste promenade, ce port de plaisance a de nombreuses facettes : il réunit les yachts étincelants et l'architecture post-moderne, les vacanciers et les locaux, l'élite, la foule et les noctambules. Le Port Olímpic, rénové pour les Jeux Olympiques de 1992, propose également de nombreux restaurants avec vue sur la mer.

Ubicado en un amplio paseo, este puerto deportivo ofrece mucho para ver y vivir: yates relucientes, arquitectura postmoderna, veraneantes y autóctonos, fiestas y amantes de la noche. Creado de la nada para los Juegos Olímpicos de 1992, también incluye muchos restaurantes con terrazas orientadas al mar.

Situato di fronte a un'ampia passeggiata, al porto c'è molto da vedere: yacht scintillanti e architettura postmoderna, turisti e gente del luogo, feste, suoni e amanti della vita notturna. Il Port Olímpic, ristrutturato in occasione dei Giochi del 1992, comprende inoltre diversi ristoranti con vista sul mare.

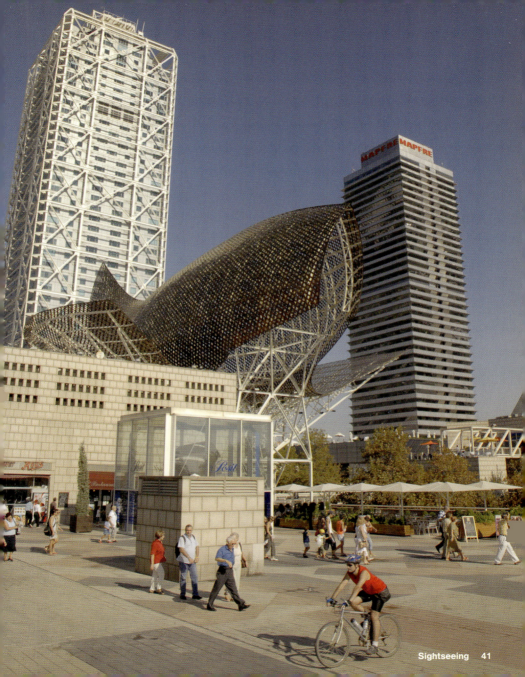

Culture
Museums Galleries Theaters Cinemas

Creativity and the spirit of innovation have a tradition in Barcelona. The city is among Europe's music metropolises and ranks as the most important publishing city of Spain. Pablo Picasso, as well as Joan Miró and Antoni Tàpies—both born in Barcelona—have left their mark here. There are more than 50 museums, nearly 90 galleries, and quite a few protected buildings, some of which are in *Modernisme*, the Catalan art nouveau.

La créativité et l'esprit d'innovation sont une tradition barcelonaise. Cette ville est une des métropoles musicales d'Europe et la principale ville d'Espagne pour l'édition. Pablo Picasso, tout comme Joan Miró et Antoni Tàpies – tous deux natifs de Barcelone – y ont laissé leur empreinte. Elle compte plus de 50 musées, près de 90 galeries, et nombre de bâtiments classés, dont les plus importants appartiennent au *Modernisme*, l'Art nouveau catalan.

La creatividad y el espíritu innovador tienen tradición en Barcelona, una de las metrópolis musicales europeas, siendo además el más importante centro editorial de España. Joan Miró, Antoni Tàpies, ambos oriundos de esta ciudad, y Pablo Picasso han dejado su impronta. Encontramos unos 50 museos, casi 90 galerías y varios edificios protegidos por ser representativos del modernismo.

Creatività e spirito di innovazione appartengono al carattere della città, che è una delle più importanti metropoli europee per la musica e il maggiore centro editoriale della Spagna. Joan Miró, Antoni Tàpies – barcellonesi entrambi – e Pablo Picasso vi hanno lasciato le loro tracce. Ci sono circa 50 musei, quasi 90 gallerie e diversi edifici protetti, alcuni espressione del *modernismo*, l'Art Nouveau catalana.

Left page: Gran Teatre del Liceu
Right page: Left Museu d'Art Contemporani, right Palau de la Música Catalana

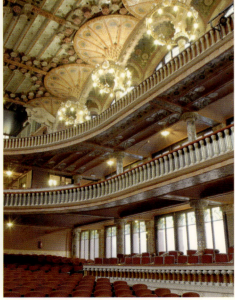

Gran Teatre del Liceu

La Rambla, 51–59
08002 Barcelona
Ciutat Vella
Phone: +34 / 933 06 41 00
www.liceubarcelona.com

Opening hours: Guided tours of the public areas Mon–Sun from 10 am (70 mins), unguided tours of the public areas Mon–Sun 11.30 am, noon, 12.30 pm and 1 pm (20 mins)
Admission: Guided tours € 8.50, unguided tours € 4
Ticketservice: +34 / 902 53 33 53, www.servicaixa.com
Public transportation: Metro Liceu
Map: No. 24

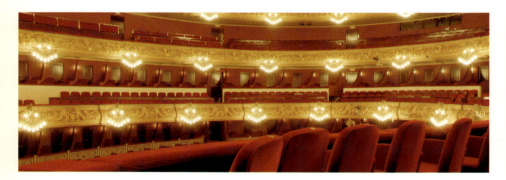

This theater is a dream of red and gold, plush and pomp: Since 1848, the most important operas have been sung here by the most famous voices in the world. It is one of the most beautiful and now also one of the most modern and largest opera houses of Europe, thanks to a complete renovation that lasted five years after a devastating fire in 1994.

Ce théâtre est un rêve d'or et de pourpre, de velours et de splendeur. Depuis 1848, les plus grands opéras sont chantés ici par les plus célèbres voix du monde. C'est un des plus beaux, et désormais un des plus grands et des plus modernes opéras d'Europe, grâce à une rénovation complète qui a duré cinq ans, après l'incendie qui l'avait dévasté en 1994.

Un sueño en rojo y oro, lujo y magnificencia. Aquí, desde 1848, las voces más famosas del mundo representan las más importantes óperas. Es uno de los palacios de ópera más bellos y grandes de Europa, siempre moderno, debido a la íntegra renovación del mismo culminada cinco años después del devastador incendio del 1994.

Un sogno in rosso e oro, soffice e sontuoso: dal 1848 le voci più famose del mondo cantano qui le maggiori opere. È uno dei più grandi ed eleganti teatri d'opera europei, e ora anche uno dei più moderni, grazie alla completa ristrutturazione – durata cinque anni – operata in seguito al devastante incendio del 1994.

Culture: Museums, Galleries, Theaters, Cinemas 45

Museu d'Art Contemporani – MACBA

Plaça dels Àngels, 1
08001 Barcelona
Ciutat Vella
Phone: +34 / 934 12 08 10
www.macba.es

Opening hours: 25th Sept to 23rd June Mon–Fri 11 am to 7.30 pm, Sat 10 am to 8 pm, Sun and legal holidays 10 am to 3 pm, 24th June to 24th Sept Mon–Fri 11 am to 8 pm, Thu to midnight, Sat 10 am to 8 pm, Sun and legal holidays 10 am to 3 pm, closed on 25th Dec and 1st Jan
Admission: € 7.50, concessions € 6, Wed (if not a legal holiday) special price € 3.50
Public transportation: Metro, bus Catalunya and Universitat
Map: No. 37

The MACBA with its white façade and clear lines, designed by Richard Meier, is itself the greatest exhibit in this collection of contemporary art. You can see works from the late 1940s to the present here. In addition to Catalan artists, works by internationally celebrated luminaries are also represented.

Conçu par Richard Meier, le MACBA, avec sa façade blanche et ses lignes claires, est en lui-même le chef-d'œuvre de cette collection d'art contemporain. On peut y voir des œuvres de la fin des années 40 à nos jours. Outre les œuvres d'artistes catalans, il présente des artistes reconnus sur le plan international.

Diseñado por Richard Meier, el mismo MACBA es una gigantesca obra de su propia colección de arte contemporánea, con su fachada blanca y sus líneas claras. Alberga obras datadas desde los años 40 hasta la actualidad, tanto de artistas catalanes, como de algunos grandes nombres de la escena internacional.

Progettato da Richard Meier, lo stesso MACBA può essere considerato il pezzo d'esposizione più imponente della raccolta, con la sua facciata bianca e le sue linee essenziali. I lavori esposti spaziano dai tardi anni '40 ad oggi. Vi sono esposte opere di artisti catalani e internazionali.

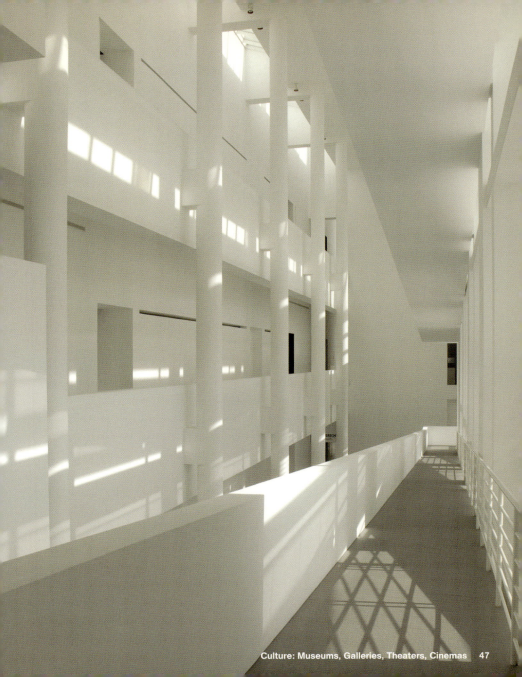

Museu Marítim

Avinguda de les Drassanes s/n
08001 Barcelona
Ciutat Vella
Phone: +34 / 933 42 99 20
www.museumaritimbarcelona.org

Opening hours: Mon–Sun 10 am to 8 pm
Admission: € 6, concession € 4.80, 1st Sat of each month (if not a legal holiday) from 3 pm free
Public transportation: Metro Drassanes
Map: No. 38

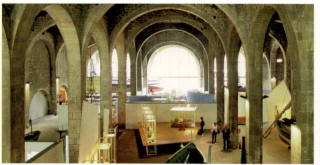
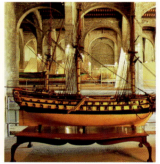

This museum documents the history of seafaring and Barcelona's rise to a maritime-trade power. One of its highlights is the reproduction of the royal galley with which Spain gained supremacy of the Mediterranean region in 1571. The *Drassanes* are among the most beautiful and best-preserved medieval docks in the world.

Ce musée présente l'histoire de la navigation et l'accession de Barcelone au rang de puissance maritime. L'un des clous de la visite est la reproduction de la galère royale avec laquelle l'Espagne établit sa suprématie sur le bassin méditerranéen en 1571. Les *Drassanes* figurent parmi les quais médiévaux les plus beaux et les mieux conservés au monde.

El Museo documenta la historia de la navegación y la ascensión de Barcelona a potencia mercantil. Destaca la reconstrucción de la Galera Real, con la que España, en el año 1571, se hizo con la supremacía de todo el Mediterráneo. Las Drassanes están considerados como uno de los muelles de época medieval más hermosos y mejor conservados del mundo.

Il museo documenta la storia della navigazione e l'ascesa di Barcellona a potenza marittima. Impressionante, in particolare, la ricostruzione della galea reale, con la quale, nel 1571, la Spagna conquistò il predominio sull'intera area mediterranea. Le *Drassanes* sono tra i più completi e meglio conservati cantieri navali medievali del mondo.

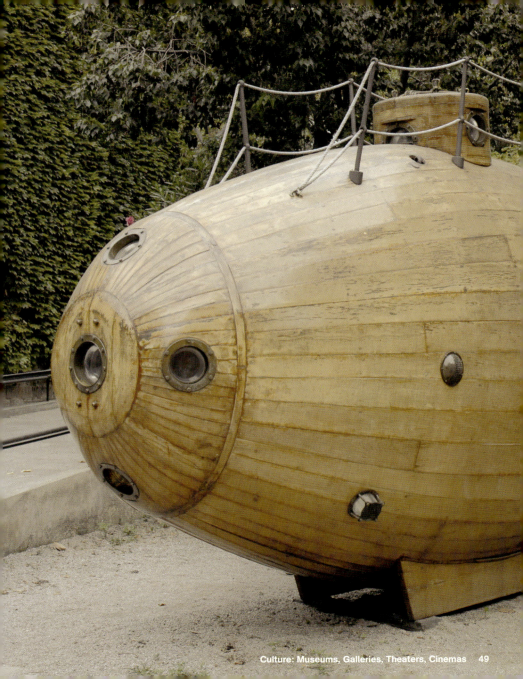

Museu Picasso

Carrer de Montcada, 15–23
08003 Barcelona
Ciutat Vella
Phone: +34 / 934 87 03 15
www.museupicasso.bcn.es

Opening hours: Tue–Sun and legal holidays 10 am to 8 pm; closed on Mon, 1st Jan, 1st May, 24th June, 25th+26th Dec
Admission: € 6, temporary exhibition € 5, combined price € 8.50, children (16 and under) free
Public transportation: Metro Arc de Triomf, Liceu and Jaume I, bus Jaume I
Map: No. 40

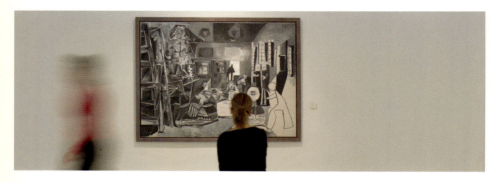

More than 3,500 drawings, paintings, graphics, and ceramics by Pablo Picassos are housed in the Palau Berenguer d'Aguilar from the 15th century. The adjoining city palaces also host temporary exhibitions. All of the artist's phases of creativity are represented here, but one of the main areas is his early years in Barcelona.

Plus de 3 500 dessins, peintures, graphiques et céramiques de Pablo Picasso sont exposés au Palau Berenguer d'Aguilar, qui date du XVe siècle. Les palais de la ville, adjacents, accueillent également des expositions temporaires. Toutes les périodes de créativité de l'artiste sont représentées ici, mais l'accent est mis sur ses jeunes années à Barcelone.

El Palau Berenguer d'Aguilar, que remonta al siglo XV, aloja más de 3 500 dibujos, pinturas, gráficos y cerámicas de Pablo Picasso; en los palacios adyacentes se alternan diversas exposiciones sobre el tema. Todas las fases de la obra del gran artista están representadas, dedicando especial atención a sus primeros años en Barcelona.

Il Palau Berenguer d'Aguilar, risalente al secolo XV, espone oltre 3 500 disegni, dipinti, grafici e ceramiche di Pablo Picasso, mentre negli edifici adiacenti hanno luogo esposizioni speciali a tema. Il catalogo è assai completo e documenta tutte le fasi creative dell'artista, con particolare attenzione ai suoi primi anni a Barcellona.

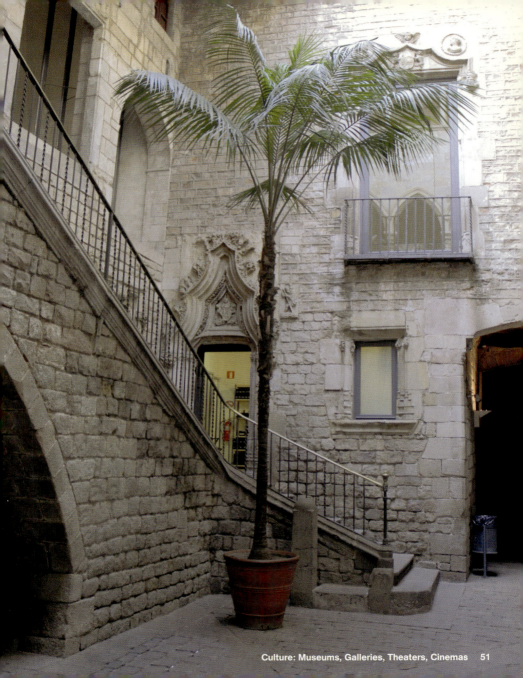

Palau de la Música Catalana

Carrer de Palau de la
Música, 4–6
08003 Barcelona
Ciutat Vella
Phone: +34 / 932 95 72 00
www.palaumusica.org

Opening hours: Guided tours Mon–Sun 10 am to 3.30 pm every 30 mins, duration 50 mins
Admission: € 9, students and senior citizens € 8
Ticket service concerts: +34 / 902 44 28 82
Special note: UNESCO World Heritage Site
Public transportation: Metro, bus Urquinaona
Map: No. 44

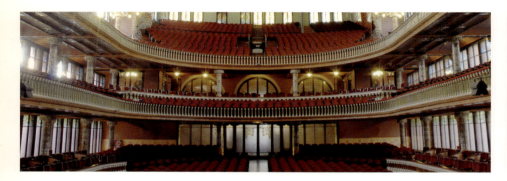

The concert house was constructed between 1905 and 1908 completely in the style of *Modernisme*, the Catalan art nouveau. The large concert hall on the upper floor with its 2,146 seats is the highlight of this overpowering building. The palace also offers perfect acoustics. Since 1997, it has been included in the World Cultural Heritage of UNESCO.

Cette salle de concert a été construite entre 1905 et 1908, entièrement dans le style moderniste, l'art nouveau catalan. La grande salle de l'étage supérieur, avec ses 2 146 places, est le joyau de ce bâtiment impressionnant. De plus, ce palais bénéficie d'une acoustique parfaite. Depuis 1997, il est classé au patrimoine mondial de l'humanité de l'UNESCO.

Esta sala de conciertos fue construida entre 1905 y 1908 con un estilo modernista, el nuevo arte catalán. El gran auditorio situado en la planta superior, con sus 2 146 asientos, constituye el apogeo de la impresionante construcción. Posee también una acústica perfecta, y en el año 1997 fue declarado patrimonio mundial por la UNESCO.

Il Palau fu costruito tra il 1905 e il 1908 in stile modernista, l'Art Nouveau catalana. L'imponente edificio culmina nella grande sala concerti del piano superiore, con 2 146 posti a sedere. L'acustica è eccezionale. Dal 1997 il Palau appartiene al patrimonio culturale mondiale dell'UNESCO.

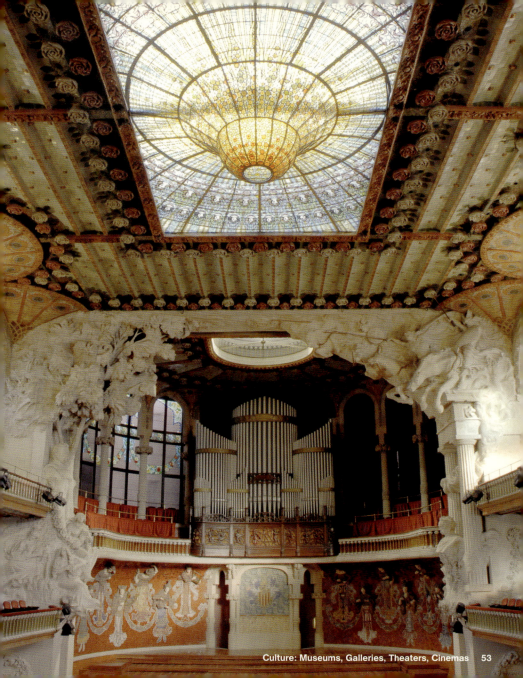

Fundació Antoni Tàpies

Carrer d'Aragó, 225
08007 Barcelona
Eixample
Phone: +34 / 934 87 03 15
www.fundaciotapies.org

Opening hours: Tue–Sun 10 am to 8 pm, closed on Mon, 25th+26th Dec and 1st+6th Jan, last admission 15 mins before closing time
Admission: € 6, concessions € 4
Public transportation: Metro Passeig de Gràcia
Map: No. 21

This foundation by Antoni Tàpies, who was born in Barcelona in 1923, is housed in a red brick building from the early Catalan *Modernisme*. Inspired by surrealism, Tàpies created increasingly abstract pictures, graphics, and objects of art. In addition to his works, temporary exhibitions of contemporary artists are held here.

Un bâtiment de brique rouge datant des débuts du *Modernisme* catalan accueille cette fondation créée par Antoni Tàpies, né à Barcelone en 1923. Inspiré par le surréalisme, Tàpies créa des tableaux, des graphiques et des objets d'art de plus en plus abstraits. La fondation organise également des expositions temporaires d'artistes contemporains.

Antoni Tàpies nació en Barcelona en el año 1923, y su fundación está alojada en una construcción de ladrillos rojos al estilo del modernismo catalán temprano. Inspirado por el surrealismo, Tàpies creó imágenes, gráficos y objetos cada vez más abstractos. Además de sus obras, se admiran otras exposiciones especiales de arte contemporáneo.

La fondazione di Antoni Tàpies, nato a Barcellona nel 1923, è ospitata in un edificio di mattoni rossi risalente all'epoca del primo modernismo catalano. Ispirato dal surrealismo, Tàpies realizzò dipinti, grafici e oggetti di astrattismo sempre crescente. Oltre alle sue opere, la fondazione propone mostre periodiche di artisti contemporanei.

Fundació Joan Miró

Avinguda de Miramar, 1
Parc de Montjuïc
08038 Barcelona
Sants-Montjuïc
Phone: +34 / 934 43 94 70
www.bcn.fjmiro.es

Opening hours: Tue–Sat 10 am to 7 pm (July–Sept to 8 pm), Thu to 9.30 pm, Sun and legal holidays 10 am to 2.30 pm, closed on Mon
Admission: Adults € 7.50, students € 5
Public transportation: Bus Parc de Montjuïc
Map: No. 22

The foundation documents not only 10,000 works by Joan Miró spanning 70 years—the light-flooded museum itself is one of Miró's works, which he realized with his friend Josep Lluís Sert. Moreover, young artists are given a forum in Espai 13. The terrace presents a wonderful view of the city.

Ce ne sont pas seulement 10 000 œuvres de Joan Miró, couvrant 70 années de création que présente la fondation : ce musée inondé de lumière est lui-même une œuvre de Miró, qu'il a réalisée avec son ami Josep Lluís Sert. Et à l'Espai 13, les jeunes artistes ont leur lieu d'expression. La terrasse offre une merveilleuse vue sur la ville.

Además de atestiguar las 10 000 obras de Joan Miró a lo largo de 70 años, el propio museo inundado de luz es una obra de Miró, realizada con su compañero Josep Lluís Sert. En el Espai 13 existe un foro para jóvenes artistas, y desde la terraza se disfruta de una fabulosa vista de la ciudad.

Non solo la fondazione presenta 10 000 opere create da Joan Miró nell'arco di 70 anni, ma il museo stesso, di una luminosità eccezionale, è opera di Miró, che lo realizzò con il suo amico e collega Josep Lluís Sert. Nell'Espai 13 è ospitato un forum per giovani artisti. Dalla terrazza si può ammirare uno splendido panorama della città.

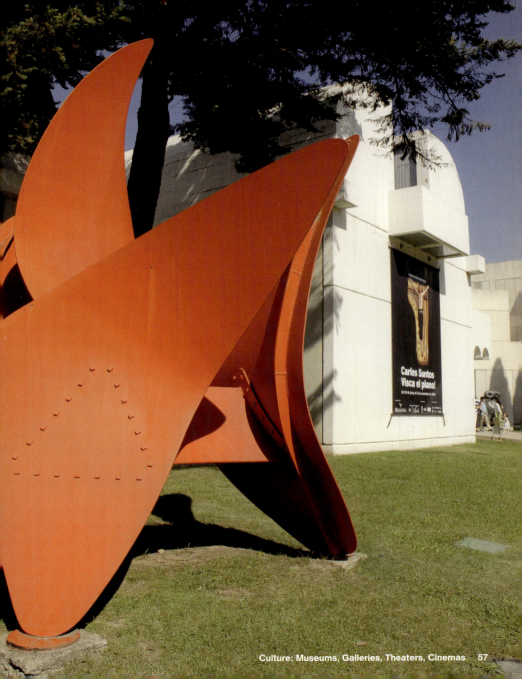

Museu Nacional d'Art de Catalunya – MNAC

Parc de Montjuïc
08038 Barcelona
Sants-Montjuïc
Phone: +34 / 936 22 03 76
www.mnac.es

Opening hours: Tue–Sat 10 am to 7 pm, Sun and legal holidays 10 am to 2.30 pm, closed on Mon
Admission: € 8.50 (valid for 2 days), free for 14 and under and 65 and over, students 30 % discount
Public transportation: Metro Espanya, bus Parc de Montjuïc
Map: No. 39

Some one-thousand years of Catalan art in one single museum: The largest collection of Romanesque art in the world, as well as works from every epoch and all of the significant Spanish artists are represented here. Palau Nacional, built for the 1929 World Exhibition, now also houses the Thyssen-Bornemisza collection.

Un millénaire d'art catalan réuni dans un seul musée : la plus grande collection d'art roman au monde, ainsi que des œuvres de chaque époque et des travaux de tous les artistes espagnols majeurs y sont présentés. Le Palau Nacional, construit pour l'Exposition Universelle de 1929, accueille à présent la collection Thyssen-Bornemisza.

Cien años de arte catalán en un mismo museo: es lo que representa la mayor colección de arte románico del mundo, con trabajos de todas las épocas y los artistas españoles más significativos. El Palau Nacional, completado en el año 1929 para la Exposición Mundial, también hospeda la colección Thyssen-Bornemisza.

Quasi mille anni di arte catalana in un solo museo: vi è esposta la più grande raccolta di arte romanica del mondo, inoltre opere di tutte le epoche e i lavori di tutti gli artisti spagnoli più significativi. Eretto nel 1929 in occasione dell'Esposizione Mondiale, il Palau Nacional ospita oggi anche la collezione Thyssen-Bornemisza.

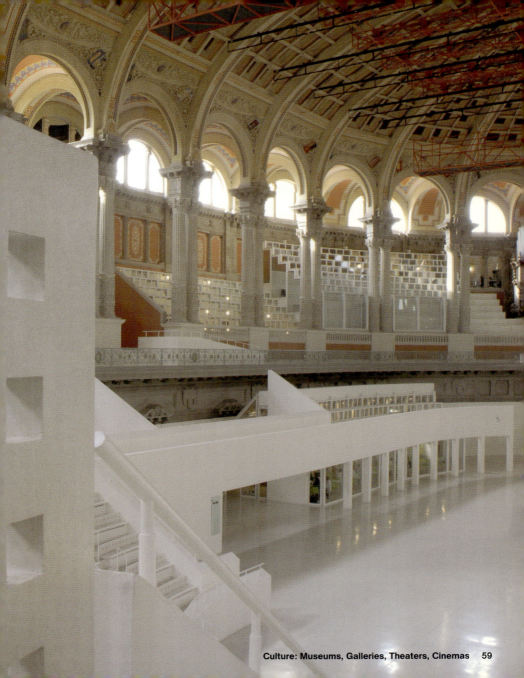

Pavelló Mies van der Rohe

Avinguda Marquès de
Comillas, 7
08038 Barcelona
Sants-Montjuïc
Phone: +34 / 934 23 40 16
www.miesbcn.com

Opening hours: Daily 10 am to 8 pm
Admission: € 3.50, students € 2, children (18 and under) free
Public transportation: Metro Espanya, bus Marqués de Comillas-Méjico
Map: No. 47

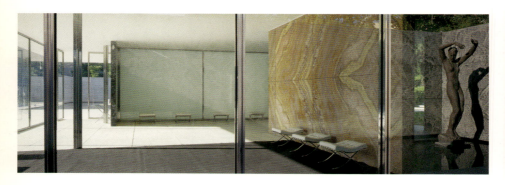

Ludwig Mies van der Rohe's flat, angular, functional pavilion of glass, steel, and marble—the German contribution to the 1929 World Exhibition—was rebuilt at its original location in 1986. It even includes the famous "Barcelona Chairs" that the Bauhaus architect designed to match the building.

Conçu par Ludwig Mies van der Rohe, ce pavillon plat, anguleux et fonctionnel fait de verre, d'acier et de marbre, contribution allemande à l'Exposition Universelle de 1929, a été reconstruit sur son emplacement originel en 1986. Il comprend même les fameuses « Chaises de Barcelone » que l'architecte du Bauhaus avait conçues pour s'harmoniser avec le bâtiment.

El pabellón de Ludwig Mies van der Rohe es plano, angulado y fríamente práctico, realizado en cristal, acero y mármol. Contribución alemana a la Exposición de 1929, fue ampliado en el año 1986 basándose en el original, junto con la célebre "silla de Barcelona", diseñada por el artista a juego con la construcción.

Il padiglione di Ludwig Mies van der Rohe – piatto, angoloso, impersonale, in vetro, acciaio e marmo, il contributo tedesco all'Expo del 1929 – è stato ampliato nel 1986 intorno al nucleo originale. Include le celebri "Poltrone di Barcellona", che l'architetto progettò in armonia con l'edificio.

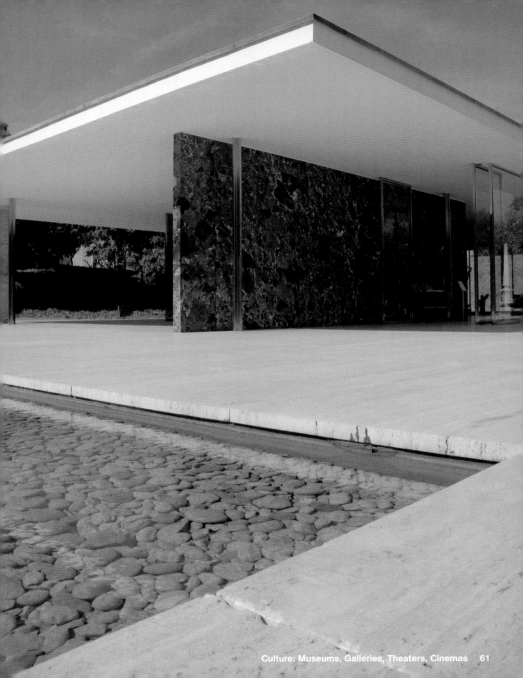

Restaurants Cafés Bars Clubs

Barcelona is one of Europe's party cities. People party into the morning hours, but the evenings begin late: Dinner is not before 9 or 10 pm. The restaurants offer everything from "tapas" to high-class cuisine. Regional specialties place a special emphasis on dishes with fish and seafood. The famous caramel-cream dessert *crema catalana* is the sweet conclusion of the meal.

Barcelone est l'une des villes d'Europe où l'on aime faire la fête. Elle se prolonge jusqu'au matin, mais les soirées commencent tard : on ne dîne pas avant 9 ou 10 heures. Les restaurants proposent de tout, depuis les tapas jusqu'à la cuisine haut de gamme. Les spécialités régionales font une place de choix aux poissons et fruits de mer. La fameuse *crema catalana* conclut le repas sur une note sucrée.

Barcelona es una de las ciudades europeas con más fiestas, que a menudo duran hasta la mañana siguiente. También la noche empieza más tarde que en el resto de Europa: aquí no se cena antes de las 9 ó 10. La oferta gastronómica es muy variada, desde las tapas hasta la cocina de alto nivel o las típicas especialidades regionales de pescado y marisco. Como dulce colofón final a nuestra comida, podemos pedir una crema catalana.

Barcellona è una delle metropoli più festaiole d'Europa. Le feste durano fino all'alba. Le serate iniziano tardi, non si cena prima delle 9 o delle 10. L'ampia offerta gastronomica spazia dalle tapas all'alta cucina; tra le specialità regionali spiccano i piatti a base di pesce e i frutti di mare. Per concludere il pasto in dolcezza, la scelta è quasi automatica: *crema catalana*.

Left page: Ot
Right page: Left Bestial, right Comerç 24

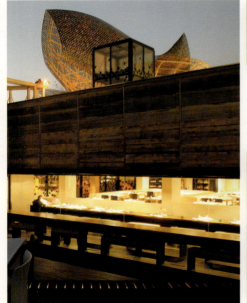

Agua

Passeig Marítim de la
Barceloneta, 30
08005 Barcelona
Ciutat Vella
Phone: +34 / 932 25 12 72
www.aguadeltragaluz.com

Opening hours: Daily 1.30 pm to 4 pm, Sat+Sun to 5 pm, daily 8.30 pm to midnight, Fri+Sat to 1 am
Prices: Average price menu € 25
Cuisine: Seafood, Mediterranean
Public transportation: Metro Barceloneta
Map: No. 1

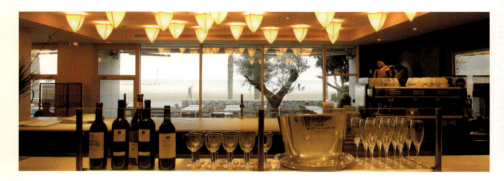

This hip restaurant directly on the beach offers the best Mediterranean cuisine with a Spanish influence. It has a terrace to see and be seen, but you can also eat inside and have a wonderful view of the ocean. Tortillas, goose liver on bread, and grilled vegetables are among the specialties that are accompanied by strong wines.

Ce restaurant à la mode donnant directement sur la plage offre une délicieuse cuisine méditerranéenne aux accents espagnols. Il possède une terrasse sur laquelle vous pouvez voir et être vu, mais vous pouvez également manger à l'intérieur et profiter de la magnifique vue sur la mer. Tortilla, foie gras d'oie sur toasts et légumes grillés sont parmi ses spécialités, accompagnées de vins charpentés.

Este local de moda, situado frente a la playa, ofrece comida hispano-mediterránea de la mejor calidad. La terraza resulta excelente para ver y ser visto, y por supuesto para comer con una maravillosa vista al mar. Entre sus especialidades destacan la tortilla y el hígado de pato con pan y verduras, así como los vinos de gran cuerpo.

Questo noto locale di fronte alla spiaggia propone un'ottima cucina mediterranea di stampo spagnolo. Chi ama stare tra la gente può pranzare in terrazza, ma anche dall'interno si gode di una stupenda vista sul mare. Tra le specialità ci sono tortilla, fegato d'oca con pane e verdure alla griglia, accompagnati da vini robusti.

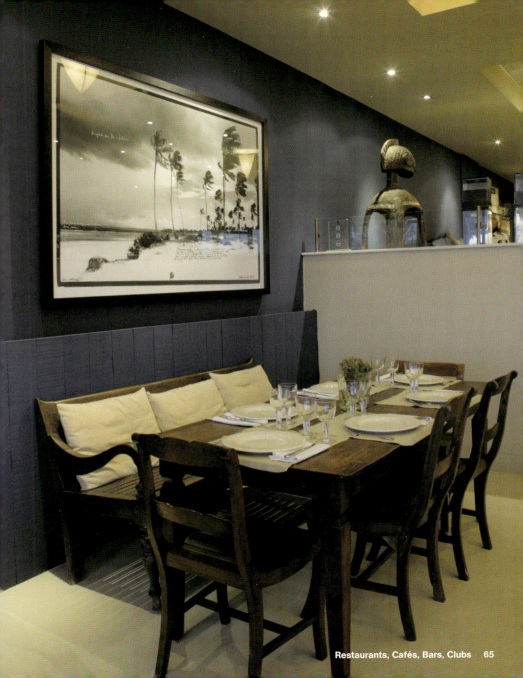

Bestial

Carrer de Ramon Trias Fargas, 2–4
08005 Barcelona
Ciutat Vella
Phone: +34 / 932 24 04 07
www.bestialdeltragaluz.com

Opening hours: Mon–Thu 1 pm to 3.45 pm and 8 pm to 11.30 pm, Fri to 12.30 am, Sat 1 pm to 4.30 pm and 8 pm to 12.30 am, Sun to 11.30 pm
Prices: Average price menu € 25
Cuisine: Mediterranean, Italian
Public transportation: Metro Ciutadella Vila Olímpica
Map: No. 6

In the shadow of the fish sculpture by star architect Frank O. Gehry, the puristic kitchen serves Italian classics ranging from pasta to pizza to risotto. The interior is also minimalist—the main attraction is the lounge-style giant terrace overshadowed by tall palms that stretches to the beach.

Tout près du poisson sculpté par l'architecte star Frank O. Gehry, ce restaurant puriste sert des classiques italiens allant des pâtes à la pizza en passant par le risotto. L'intérieur est également minimaliste : l'attraction principale en est l'immense terrasse qui s'étend, tel un lounge, jusqu'à la plage à l'ombre des palmiers.

A la sombra de la escultura en forma de pez del célebre arquitecto Frank O. Gehry, la cocina purista sirve los clásicos platos italianos, desde pasta y pizza hasta risotto. La decoración es minimalista, su principal atracción es la enorme terraza protegida por palmeras al estilo de un lounge, que se extiende hasta la playa.

All'ombra della scultura-pesce del celebre architetto Frank O. Gehry, questo ristorante dalla cucina assai selettiva propone classici piatti italiani come pasta, pizza e risotti. Anche l'interno è minimalista: la zona più piacevole e senz'altro la vasta terrazza in stile lounge, circondata da palme, che si estende fino alla spiaggia.

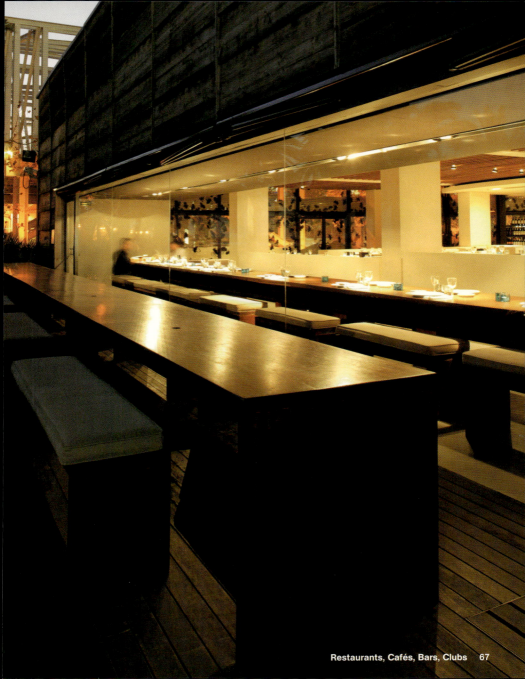

Boadas Cocktail Bar

Carrer dels Tallers, 1
08001 Barcelona
Ciutat Vella
Phone: +34 / 933 18 88 26

Opening hours: Mon–Thu noon to 2 am, Fri+Sat noon to 3 am, legal holidays noon to 3 pm and 6 pm to 2 am, closed on Sun
Prices: Average price cocktail € 6
Public transportation: Metro Catalunya
Map: No. 7

Enjoy cocktails in the best tradition: The founder of this little bar learned his craft at Ernest Hemingway's favorite pub El Floridita in Havanna. His family has continued his work. The bartenders wear dark clothes, their advice is reliable, and their discretion is as legendary as their cocktails.

Appréciez vos cocktails dans la plus pure tradition : le fondateur de ce petit bar a appris son art dans le pub favori d'Ernest Hemingway, le Floridita, à la Havane. Sa famille poursuit son œuvre. Les barmen portent des vêtements sombres, leurs conseils sont fiables, et leur discrétion aussi légendaire que leurs cocktails.

Saborear cócteles de la mayor tradición: el fundador de este pequeño bar aprendió su oficio en la taberna favorita de Ernest Hemingway, La Floridita en La Habana, y su familia ha tomado el testigo de su labor. Los camareros llevan traje oscuro, le asesoran con gran habilidad, y su discreción es tan legendaria como sus cócteles.

La miglior tradizione in fatto di cocktail: il primo proprietario di questo piccolo bar aveva appreso il mestiere nella taverna preferita da Ernest Hemingway all'Avana, El Floridita. La sua famiglia prosegue la tradizione. I barman vestono di scuro, i loro consigli sono affidabili e vantano una discrezione leggendaria quantc i loro cocktail.

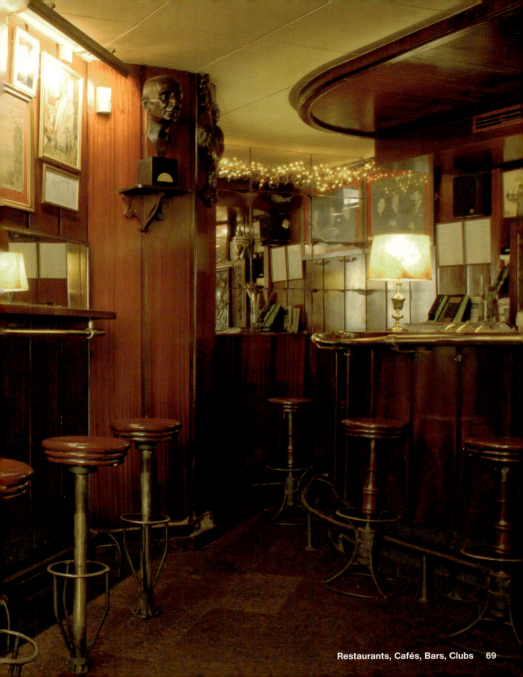

Café de L'Acadèmia

Carrer Lledó, 1
08002 Barcelona
Ciutat Vella
Phone: +34 / 933 15 00 26

Opening hours: Mon–Fri 9 am to noon (morning only bar and breakfast), 1.30 pm to 4 pm and 8.45 pm to 11.30 pm, closed on Sat, Sun and legal holidays
Prices: Average price lunch menu € 13, dinner € 30 to € 36 incl. wine
Cuisine: Mediterranean, Catalan
Public transportation: Metro Jaume I
Map: No. 9

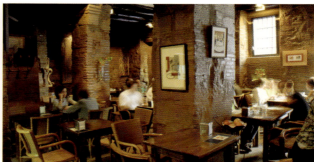

At one of the loveliest plazas in the city under the tower of the Sant Just church, this small but elegant restaurant offers Catalan classics—prepared in a way that is modern and fresh from the market. The guests enjoy the respectable cuisine at moderate prices and dine outside between Gothic façades in front of a fountain.

Sur une des plus jolies places de la ville, sous le clocher de l'église Sant-Just, ce restaurant petit mais élégant propose des classiques catalans préparés de manière moderne avec les produits du marché. Les convives apprécient sa cuisine respectable pour un prix raisonnable et dînent dehors entre les façades gothiques, devant une fontaine.

Este restaurante, de reducido tamaño y gran elegancia, se encuentra en una de las plazas más bellas de la ciudad, bajo la torre de la Iglesia de Sant Just. Ofrece platos catalanes clásicos y modernos, con género siempre recién traído del mercado. Los huéspedes disfrutan de un auténtico arte culinario a precios moderados, y comen al aire libre entre fachadas góticas.

In una delle più belle piazze della città, sotto il campanile della chiesa di Sant Just, questo piccolo ma elegante ristorante propone piatti classici catalani, rivisitati e preparati con ingredienti freschissimi. Gli ospiti apprezzeranno una buona cucina a prezzi moderati, seduti all'aperto davanti alla fontana, tra le facciate gotiche.

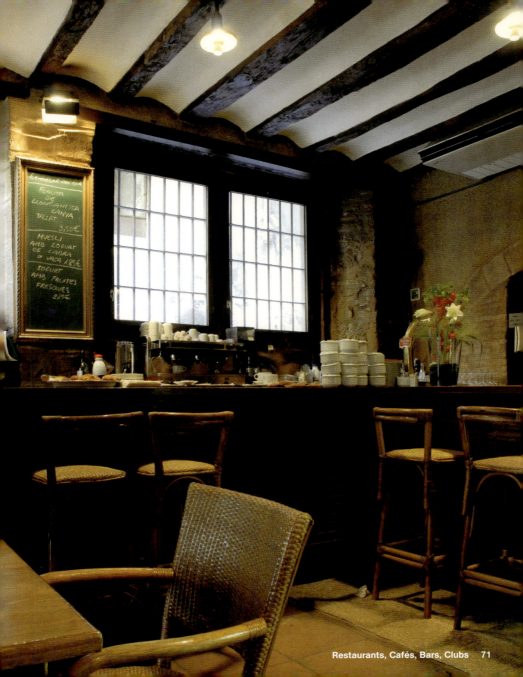

Café Schilling

Carrer de Ferran, 23
08002 Barcelona
Ciutat Vella
Phone: +34 / 933 17 67 87
www.cafeschilling.com

Opening hours: Daily 10 am to 3 am
Prices: Bocadillo € 5, Café con Leche € 1.10
Cuisine: Pastries, paninis
Public transportation: Metro Liceu, Jaume I
Map: No. 10

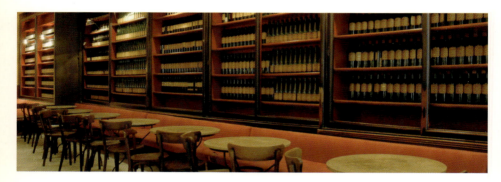

This café in the Gothic Quarter offers delicious tapas in Belle-Époque ambience. It draws many tourists, but also a local crowd. You can leisurely sip a cup of *Café con Leche* in the classic coffeehouse atmosphere as you people-watch — and witness the scenes of everyday life.

Ce café du quartier gothique propose de délicieuses tapas dans une ambiance Belle Époque. Il attire de nombreux touristes, mais aussi une foule d'autochtones. Vous pourrez siroter tranquillement une tasse de *café con leche* dans cette atmosphère de café traditionnel, regarder les passants et assister à des scènes de la vie quotidienne.

Este café situado en el Barrio Gótico, propone deliciosas tapas en un entorno de Belle-Époque. Atrae a muchos turistas y también a clientela local. En su clásico ambiente de cafetería con tradición, podemos degustar cómodamente una taza de café con leche y observar a la gente, convirtiéndonos en testigos de la vida cotidiana.

Questo caffè del Quartiere Gotico offre squisite tapas in un ambiente Belle Époque. È apprezzato sia dai turisti sia dalla clientela locale. In una classica e confortevole atmosfera da coffee house, si può sorseggiare una tazza di *café con leche* e osservare il viavai e la vita quotidiana della città.

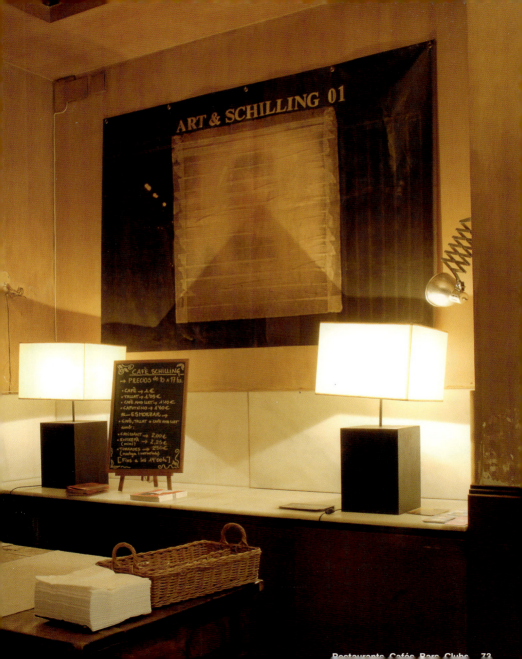

Carpe Diem Lounge Club & Restaurant

Passeig Marítim, 32
08005 Barcelona
Ciutat Vella
Phone: +34 / 932 24 04 70
www.cdlcbarcelona.com

Opening hours: Daily 2 pm to 3 am
Prices: Average price drinks € 10, food € 25
Cuisine: Mediterranean, Asian
Public transportation: Metro Ciutadella Vila Olímpica
Map: No. 11
Editor's tip: Wear decent socks! Guests have to take off their shoes on the lawn for sunbathing.

One of the hottest clubs of the city is inside of two giant Bedouin tents close to the beach. In the afternoon, you can enjoy a cocktail here in a lounge atmosphere on leather sofas that are as big as beds. The interior is Indian-influenced. The club turns into a funky party zone in the later hours.

Un des clubs les plus fréquentés de la ville se trouve dans deux tentes de bédouin géantes, près de la plage. L'après-midi, on s'y détend avec un cocktail dans une atmosphère de lounge sur des canapés de cuir grands comme des lits. A l'intérieur, la décoration s'inspire de l'Inde. En fin de soirée, le club devient une scintillante discothèque.

Bajo dos enormes tiendas beduinas cercana a la playa, se oculta uno de los clubes más anunciados de la ciudad. Por la tarde podemos relajarnos en un ambiente lounge, tomando un cóctel sobre sofás de cuero del tamaño de camas, y por la noche, disfrutar de las mejores fiestas. La decoración se inspira en la India.

All'interno di due enormi tende beduine vicino alla spiaggia si nasconde uno dei club più alla moda della città. Nel pomeriggio ci si può rilassare sorseggiando un cocktail su divani in pelle grandi come letti, in atmosfera lounge. L'arredamento interno è di ispirazione indiana. La sera, invece, il club diventa teatro di feste scatenate.

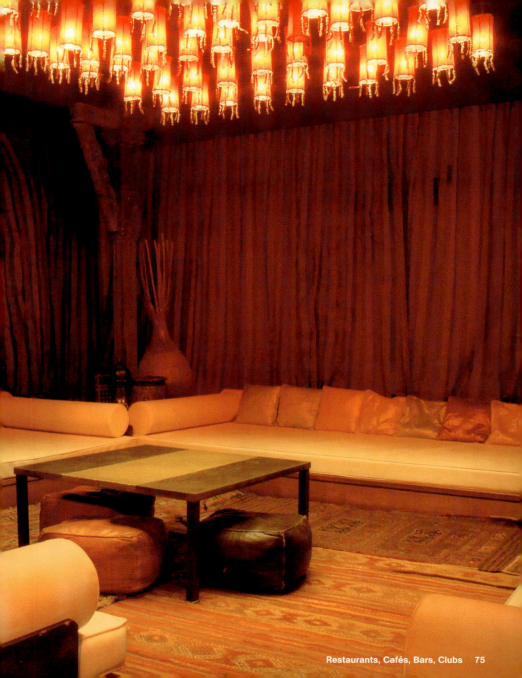

CheeseMe

Plaça Jacint Reventós s/n
(opposite Calle Argentería, 53)
08003 Barcelona
Ciutat Vella
Phone: +34 / 932 68 11 27
www.cheeseme.org

Opening hours: Daily breakfast from 9 am, meals 1 pm to 2 am
Prices: Average price lunch € 11, dinner € 35
Cuisine: Cheese dishes, Nouvelle Cuisine, Tapas
Public transportation: Metro, bus Jaume I
Map: No. 17

The name says it all: With very few exceptions, every dish at CheeseMe has cheese in it, from the starters to the desserts. The food is not always that light, but the innovative taste experiences have quickly given the little restaurant a cult status. The ceiling-high windows allow guests to look out at the terrace and the plaza.

Tout est dans le nom : à de très rares exceptions près, chaque plat du CheeseMe contient du fromage, des entrées au dessert. La nourriture n'est pas toujours légère, mais ses innovations culinaires ont rapidement fait de ce restaurant une adresse culte. Ses fenêtres, hautes jusqu'au plafond, permettent de contempler la terrasse et la place.

El nombre ya lo dice todo: en CheeseMe es casi imposible encontrar un plato que no incluya queso, desde los entrantes hasta los postres. Y no sólo platos sencillos, sino también innovadoras experiencias culinarias que han otorgado rápidamente al pequeño restaurante el estatus de culto. La vista que se dibuja a través de las altas ventanas es de enorme belleza.

Il nome dice già tutto: in CheeseMe è quasi impossibile trovare un piatto che non contenga formaggio, dagli antipasti al dessert. I piatti non sono sempre leggeri, ma le esperienze di sapore innovative hanno rapidamente conferito a questo piccolo ristorante una fama particolare. Le alte finestre danno sulla terrazza e sulla piazza.

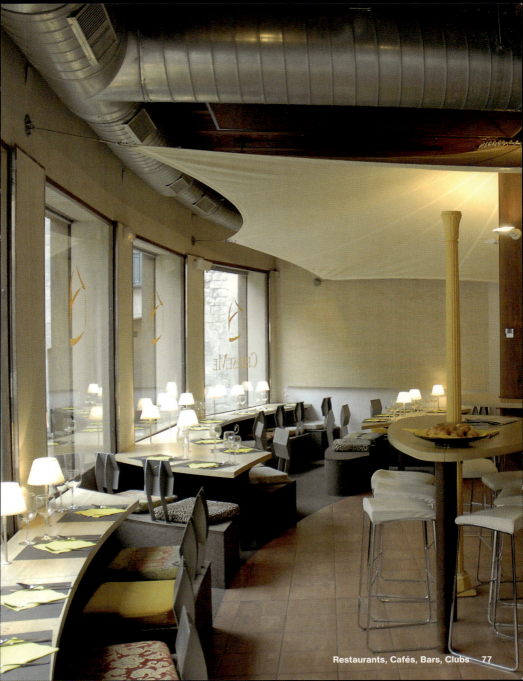

Comerç 24

Carrer del Comerç, 24
08003 Barcelona
Ciutat Vella
Phone: +34 / 933 19 21 02
www.comerc24.com

Opening hours: Tue–Fri 1.30 pm to 4 pm and 8.30 pm to midnight, Sat 8.30 pm to midnight
Prices: Average price menu € 55
Cuisine: Asian, Andalusian, Catalan, Italian, American
Public transportation: Metro Arc de Triomf
Map: No. 18
Editor's tip: The pupils of Adrian Ferran (El Bulli) are much sought after. Make an early reservation!

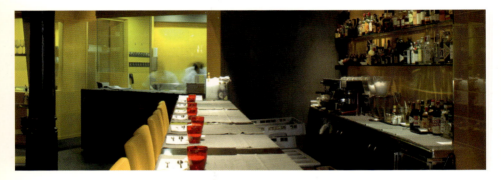

Legendary tapas in a puristic ambience: The cuisine is Catalan here, inspired by Asian, Italian, Andalusian, and even American influences. For example, the original and highly creative kitchen of chef Carles Abellán serves a hamburger with *foie gras* and truffles.

Des tapas de légende dans une ambiance puriste : la cuisine est catalane, inspirée par l'Asie, l'Italie, l'Andalousie et même l'Amérique. Le chef Carles Abellán, à la cuisine originale et extrêmement créative, sert notamment un hamburger au foie gras et aux truffes.

Tapas legendarias en un ambiente purista: aquí se cocina a la catalana, con inspiraciones e influencias asiáticas, italianas, andaluzas e incluso americanas. Como resultado, la cocina original y altamente creativa del chef Carles Abellán sirve, por ejemplo, hamburguesas con *foie gras* y trufas.

Tapas leggendarie in un ambiente puristico: qui la cucina è catalana, ispirata da influssi asiatici, italiani, andalusi e persino americani. Il risultato è una cucina creativa e altamente innovativa ideata dallo chef Carles Abellán che propone, ad esempio, hamburger con *foie gras* e tartufi.

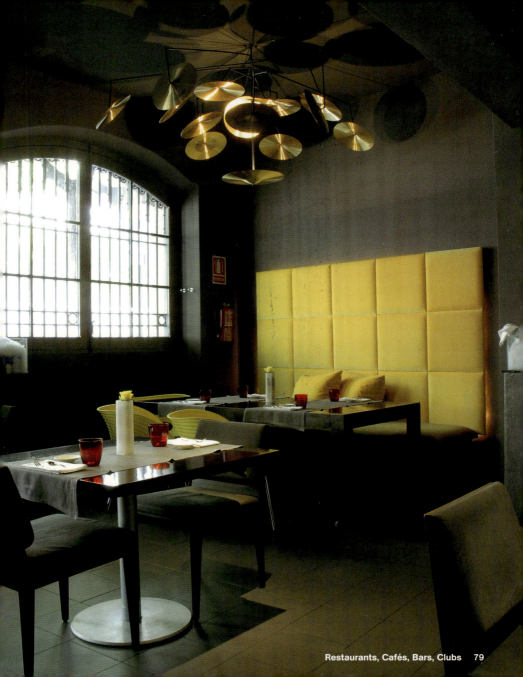

Cuines Santa Caterina

Avinguda de Francesc
Cambó s/n
08002 Barcelona
Ciutat Vella
Phone: +34 / 932 68 99 18
www.grupotragaluz.com

Opening hours: Daily 1 pm to 4 pm and 8 pm to 11.30 pm, Thu–Sat to 12.30 am
Prices: Average price menu € 23
Cuisine: Tapas, vegetarian, Oriental, Asian, Mediterranean
Public transportation: Metro Jaume I
Map: No. 19

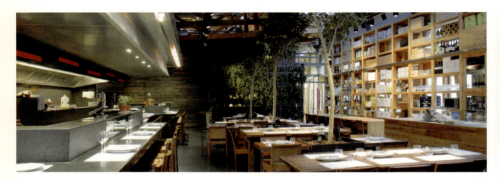

At this post-modern design temple, situated in the center of a market hall, people sit either at long tables or behind one of the very tall fichus trees. The restaurant offers snacks from the tapas bar or à la carte meals: sushi and tempura, homemade ravioli, or delicious paella.

Dans ce temple du design post-modern, situé au centre d'un marché couvert, les clients s'assoient devant de longues tables ou derrière de hauts ficus. Le restaurant propose des en-cas au bar à tapas ou des plats à la carte : sushi et tempura, ravioli maison ou une délicieuse paella.

En este templo del diseño postmoderno, ubicado en el centro de un mercado cubierto, nos sentamos alrededor de largas mesas o detrás de uno de los ficus que superan la altura de los hombres. La carta propone tapas, por supuesto, o especialidades a la carta: sushi y témpura, raviolis caseros o suculentas paellas.

In questo tempio del design postmoderno, situato al centro di un mercato coperto, ci si accomoda ai lunghi tavoli oppure dietro le altissime piante di ficus. Oltre agli stuzzichini del bar de tapas, si può scegliere tra le proposte del menu: sushi e tempura, ravioli fatti in casa o una squisita paella.

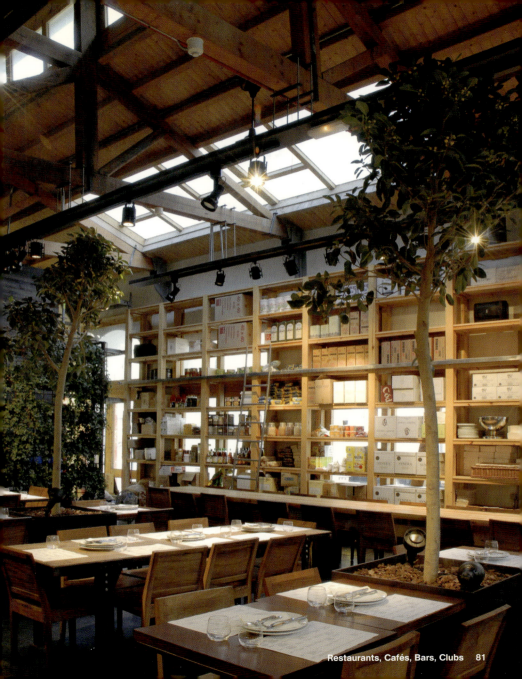

Els Quatre Gats

Carrer Montsió, 3
08002 Barcelona
Ciutat Vella
Phone: +34 / 933 02 41 40
www.4gats.com

Opening hours: Mon–Sat 9 am to 2 am, Sun 5 pm to 2 am
Prices: Average price menu € 30
Cuisine: Traditional Catalan
Public transportation: Metro Liceu and Jaume I
Map: No. 20

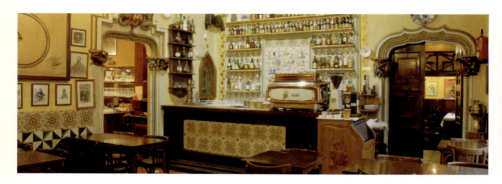

Already in 1897, people dined at the "Four Cats," which was a popular Parisian-style meeting place for artists. Pablo Picasso exhibited here and designed the menu. Antoni Gaudí was also among the regulars. As in earlier days, you can hear piano music. Both the Spanish specialties and the atmosphere are worth the visit.

En 1897 déjà, les gens dînaient aux « Quatre chats », un lieu de rencontre prisé des artistes de l'école parisienne. Pablo Picasso y a exposé et en a créé le menu. Antoni Gaudí faisait aussi partie des habitués. Comme à l'époque, vous pouvez y écouter du piano. Les spécialités espagnoles, tout comme l'atmosphère, valent le détour.

Ya en 1897 se comía en los Cuatro Gatos, por aquel entonces lugar de encuentro de artistas al estilo parisino. Así, Pablo Picasso dio forma al menú, y también Antoni Gaudí se encontraba entre los comensales. Tanto las especialidades españolas como el ambiente gratifican la visita, tanto ahora como entonces, al son de música de piano.

Già nel 1897 si pranzava ai "Quattro Gatti", ritrovo di stile parigino prediletto da artisti. Pablo Picasso, che esponeva qui i propri quadri, disegnò il menu, e anche Antoni Gaudí faceva parte degli habitué. Ancora oggi qui echeggia il suono di un pianoforte. Le specialità spagnole e l'atmosfera ne fanno un posto da visitare.

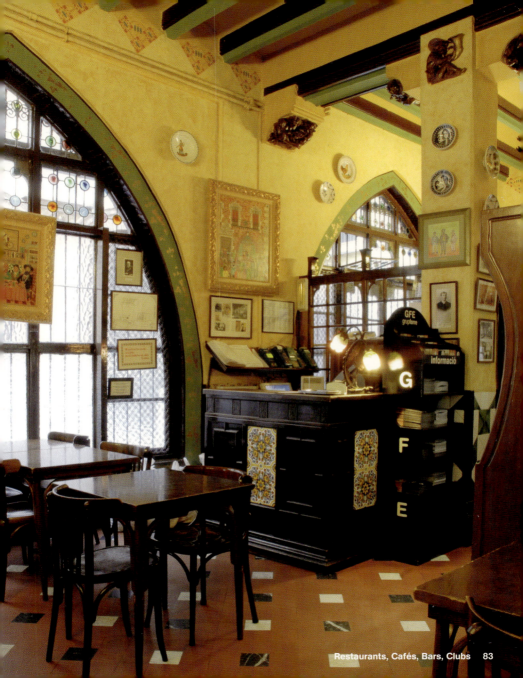

Rita Blue

Plaça de Sant Agustí s/n
08001 Barcelona
Ciutat Vella
Phone: +34 / 933 42 40 86
www.ritablue.com

Opening hours: Mon–Fri 7 pm to 2 am, Sat+Sun 7 pm to 3 am
Prices: Average price menu € 25
Cuisine: Cocktail bar, snacks, International, Mediterranean, Mexican
Public transportation: Metro Liceu, Catalunya
Map: No. 51

Rita Blue sparkles in a cool retro look, with disco balls and the matching style of lamps and decoration in the vicinity of the Rambles. House and techno music rule on the weekends. The trendy bar offers cocktails that really pack a punch, but you can also eat here: snacks and Mexican or Mediterranean main courses.

Tout près des Rambles, le Rita Blue pétille avec son look rétro, ses boules à facettes, ses lampes et sa décoration assortis. La techno et la house y règnent le week-end. Le bar tendance propose des cocktails musclés, mais on peut également y manger : en-cas et plats mexicains ou méditerranéens.

Junto a las Ramblas, el Rita Blue resplandece en su cuidado aire retro, con esferas luminosas, lámparas y otras decoraciones a tono. Los fines de semana predomina la música house y tecno. El elegante bar ofrece cócteles y aperitivos con un toque especial, y es posible degustar excelente comida mexicana y mediterránea.

Nei pressi delle Ramblas, il Rita sfavilla nel suo studiato look retro, con sfera luminosa, lampade e decorazione nello stesso stile. Al weekend si suona musica house e techno. L'elegante bar offre fantastici cocktail, ma si può anche mangiare: tapas e pietanze messicane e mediterranee.

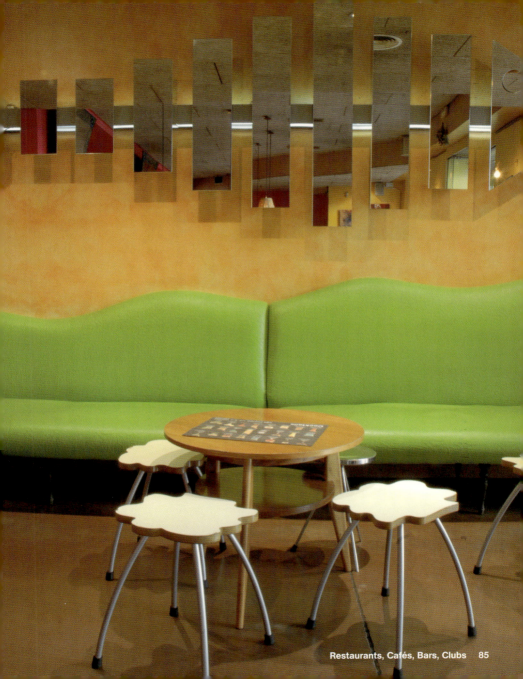

Torre D'Alta Mar

Passeig de Joan de Borbó, 88
08003 Barcelona
Ciutat Vella
Phone: +34 / 932 21 00 07
www.torredealtamar.com

Opening hours: Mon 7 pm to 11.30 pm, Tue–Sat 1 pm to 3.30 pm and 7 pm to 11.30 pm
Prices: Average price menu € 85
Cuisine: Catalan, Mediterranean
Public transportation: Metro Barceloneta
Map: No. 55

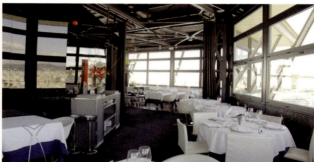

Feasting with a view in a former cable-railway tower: At a height of 246 ft, you can see the panorama of the entire city and dine in a 1970s retro-look interior. The innovative kitchen with its Catalan classics that have influences from other Mediterranean countries provides a real culinary treat.

Savourez votre repas et la vue dans une ancienne tour de funiculaire. A 75 m de haut, vous pourrez contempler la ville entière et dîner dans un cadre évoquant les années 70. La cuisine inventive, avec ses classiques catalans revisités à la mode d'autres pays méditerranéens, est un vrai plaisir pour le palais.

Darse un banquete panorámico en una antigua torre del funicular: a 75 m de altura uno puede abrazar con la vista toda la ciudad. La decoración es al estilo de los años 70. La innovadora cocina integra los clásicos catalanes con influencias de otros países mediterráneos, creando auténticos deleites culinarios.

Mangiare squisitezze e ammirare il panorama da un'ex torre della teleferica: da un'altezza di 75 m lo sguardo spazia sull'intera città. L'arredamento è in stile retro anni '70, e l'innovativa cucina, che punta su piatti classici catalani con influssi di altri paesi mediterranei, trae dalla combinazione sublimi piaceri culinari.

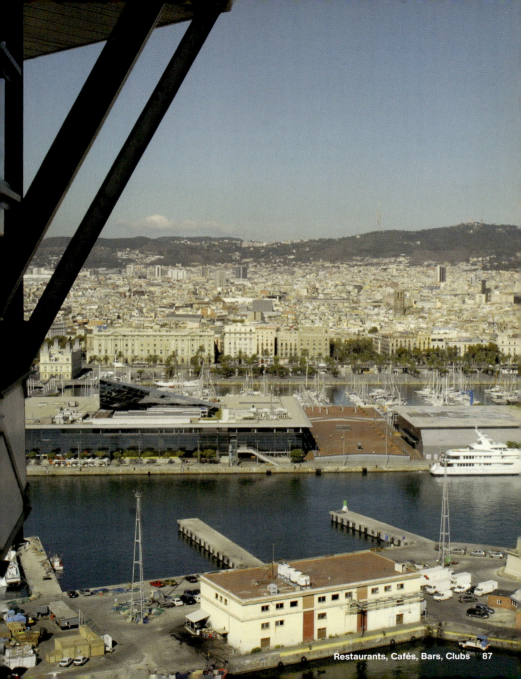

Casa Calvet

Carrer de Casp, 48
08010 Barcelona
Eixample
Phone: +34 / 934 12 40 12
www.casacalvet.es

Opening hours: Mon–Sat 1 pm to 3.30 pm and 8.30 pm to 11 pm, closed on Sun and legal holidays
Prices: Average price menu € 70
Cuisine: Classic Mediterranean
Public transportation: Metro Urquinaona
Map: No. 13

Outstanding Catalan cuisine, refined by subtle Asian influences, has been offered since 1994 in this building designed by Antoni Gaudí. Chef Miquel Alija adapts the menu to the seasons: This means that you can order venison, mushrooms, and truffles here, as well as fish and seafood. The ambience is also enchanting.

Depuis 1994, ce bâtiment conçu par Antoni Gaudí propose une extraordinaire cuisine catalane, exaltée par de subtiles influences asiatiques. Le Chef Miquel Alija adapte le menu aux saisons : ici vous pouvez commander gibier, champignons et truffes, ainsi que poisson et fruits de mer. L'ambiance est tout aussi envoûtante.

En una construcción diseñada por Antoni Gaudí, desde 1994 se puede gozar de excelente cocina catalana, ennoblecida por ligeras influencias asiáticas. La carta, escogida por el chef Miquel Alija, se adapta a la época del año, proponiendo carne de caza, champiñones y trufas, además de pescado y marisco. El ambiente es igualmente fascinante.

All'interno di un edificio progettato da Antoni Gaudí, qui dal 1994 si gusta eccellente cucina catalana, nobilitata da lievi influssi asiatici. Il menu, curato dallo chef Miquel Alija, varia secondo la stagione: troviamo così selvaggina, funghi e tartufi, ma anche pesce e frutti di mare. L'ambiente è altrettanto affascinante.

Taktika Berri

Carrer de València, 169
08011 Barcelona
Eixample
Phone: +34 / 934 53 47 59

Opening hours: Mon–Fri 1 pm to 4 pm and 8.30 pm to 11 pm, Sat 1 pm to 4 pm, closed Sun
Prices: Average price menu € 40
Cuisine: Basque, Tapas
Public transportation: Metro Universitat
Map: No. 53

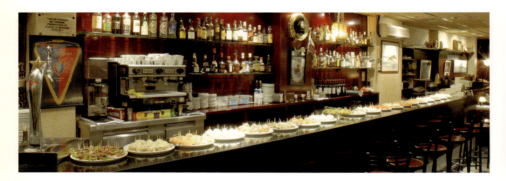

One of the indisputably best addresses in Barcelona for tapas is the Taktika Berri. Because of the Basque orientation of the kitchen, tapas are called *Pintxos* here and are accompanied by *Txakilo*, a light, fruity white wine from the Basque Provinces. There is no menu. The food is fresh daily and always top quality.

Taktika Berri est sans conteste l'une des meilleures adresses de Barcelone pour les tapas. En raison des influences basques de sa cuisine, les tapas s'appellent ici *Pintxos* et sont accompagnées de *Txakilo*, un vin blanc léger et fruité du pays basque. Il n'y a pas de menu, mais la nourriture est fraîche et toujours de la plus grande qualité.

Sin ninguna duda, el Taktika Berri es una de las mejores citas para degustar tapas en Barcelona. Preparadas al estilo vasco, aquí las tapas se llaman pintxos y van acompañadas por txakilo, un vino blanco ligero y afrutado del País Vasco. No hay menú, el género es fresco, del día, y siempre de la mejor calidad.

Il Taktika Berri è indiscutibilmente tra i migliori indirizzi della città per le tapas. Vista l'impostazione basca della cucina, qui le tapas si chiamano *pintxos* e si accompagnano con *txakolí*, il vino bianco leggero e fruttato originario dei Paesi Baschi. Non è previsto menu, il cibo è fresco di giornata e sempre della migliore qualità.

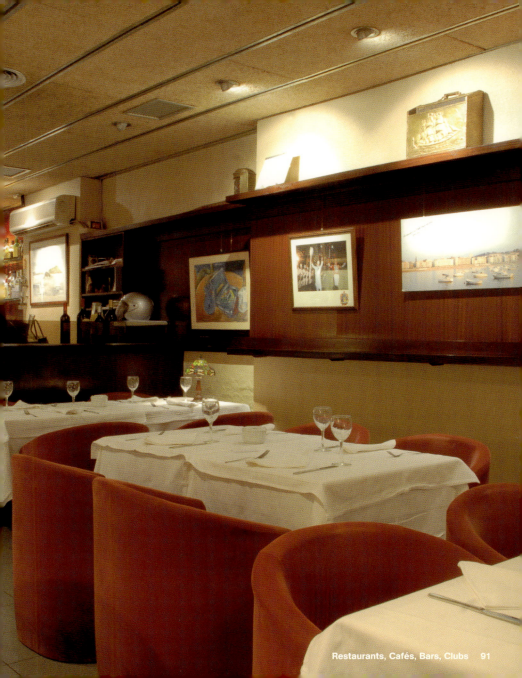

Ot

Carrer de Còrsega, 537
08012 Barcelona
Gràcia
Phone: +34 / 934 35 80 48
www.otrestaurant.net

Opening hours: Mon 8.30 pm to 11 pm, Tue–Sat 1.30 pm to 3.30 pm and 8.30 pm to 11 pm, closed on Sun
Prices: Average menu € 50
Cuisine: Nouvelle Cuisine, Mediterranean, Fusion
Public transportation: Metro Sagrada Família, bus Carrer de la Indústria
Map: No. 42

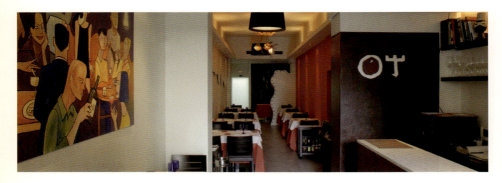

Dining as if you were visiting friends is the concept of this small, stylishly designed restaurant. Chef Ferran Caparrós interprets traditional specialties in an original way. The culinary highlight: the tasting menu with two starters and main courses each that are perfectly harmonized, as well as two different desserts.

Dîner comme chez des amis, c'est le concept de ce petit restaurant très design. Le Chef Ferran Caparrós interprète les spécialités traditionnelles de manière originale. Le must culinaire : le menu dégustation avec ses deux entrées et plats principaux en parfaite harmonie, et bien sûr ses deux desserts différents.

Comer como en casa de amigos: éste es el concepto del pequeño restaurante, decorado con mucho estilo. Las especialidades tradicionales son interpretadas de forma original por el chef Ferran Caparrós. Para probar: el menú degustación, con sus entrantes, primeros platos y postres perfectamente coordinados.

Mangiare come a casa di amici, è questo il concetto di questo piccolo ed elegante ristorante. Le specialità tradizionali vengono rivisitate con originalità dallo chef Ferran Caparrós. Da non perdere il menu degustazione, con due percorsi a scelta, entrambi composti da antipasto e piatto principale perfettamente combinati tra loro e da due diversi dessert.

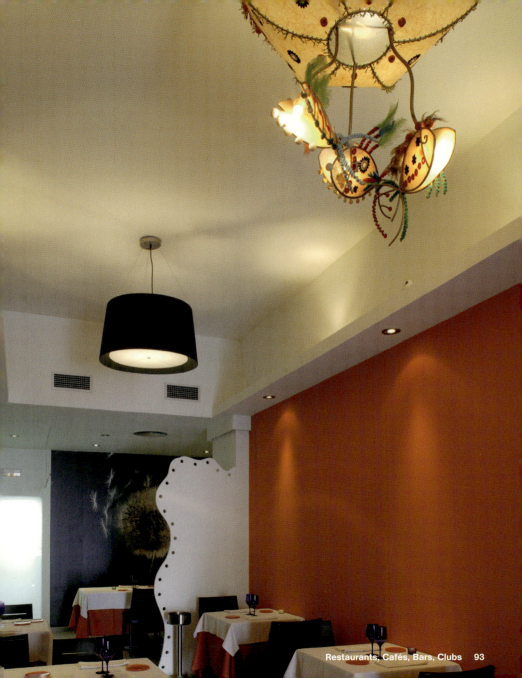

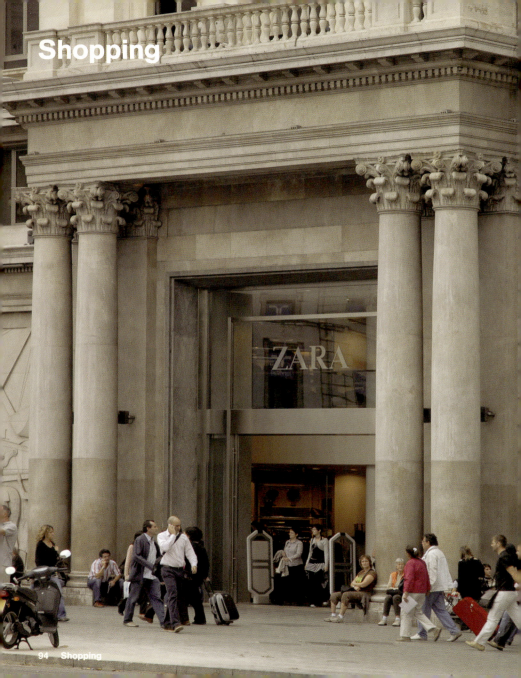
Shopping

Exquisite boutiques, glittering shopping palaces, or colorful markets—Barcelona offers a wide diversity of shopping possibilities. You can find design products for the home and closet in the Passeig de Gràcia. The Rambles offers flowers, young fashion, and souvenirs. Antiques are available at Barri Gòtic and designer furniture in the El Born quarter. The prices in Barcelona are astonishingly moderate.

Des boutiques raffinées, des centres commerciaux scintillants, des marchés colorés : Barcelone est le paradis du shopping. Le Passeig de Gràcia est le domaine des objets design pour la maison, de l'habillement et des chaussures. Sur les Rambles, vous trouverez des fleurs, la mode pour les jeunes et des souvenirs. Les antiquités se trouvent au Barri Gòtic et les meubles de créateurs dans le quartier d'El Born. A Barcelone, les prix sont étonnement raisonnables.

Selectas boutiques, relucientes palacios del consumo o mercados multicolores – Barcelona ofrece todo tipo de posibilidades de compra. En el Passeig de Gràcia el diseño para el hogar y la decoración están bien representados, en las Ramblas encontramos flores, moda joven y souvenirs, en el Barri Gòtic antigüedades y en el barrio de El Born muebles de diseño, todo a precios sorprendentemente moderados.

Boutique d'alta classe, luccicanti templi del consumo o variopinti mercati: Barcellona offre svariate possibilità per lo shopping. Sul Passeig de Gràcia ci sono innumerevoli negozi di design per la casa e abbigliamento, sulle Ramblas troviamo fiori, moda giovane e souvenir, nel Barri Gòtic antiquariato e nel quartiere El Born mobili di design. Per di più, a Barcellona i prezzi sono sorprendentemente moderati.

Left page: Zara, Passeig de Gràcia
Right page: Left Joan Strada, right Massimo Dutti

Caelum

Carrer de la Palla, 8
08002 Barcelona
Ciutat Vella
Phone: +34 / 933 02 69 93

Opening hours: Mon 5 pm to 8.30 pm, Tue–Thu 10.30 am to 8.30 pm, Fri+Sat to midnight, Sun 11.30 am to 9 pm
Products: Pastries, sweets, liqueurs
Public transportation: Metro Liceu
Map: No. 8

 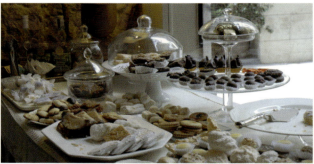

This is where you can buy cake, cookies, marzipan and candy, honey and preserves, wine, and liquor—all made by nuns and monks. These delicacies can be sampled at the adjoining tea salon in the cellar. The lovely store offers novel, beautifully packaged, and very popular little presents.

Ici, vous pourrez acheter gâteaux et biscuits, pâtes d'amande et friandises, miel et conserves, vins et liqueurs – tous confectionnés par des nonnes et des moines. Ces délices peuvent être dégustés au salon de thé, dans la cave. Cette charmante boutique propose de petits cadeaux originaux, joliment emballés et très appréciés.

Aquí encontramos tartas, pasteles, mazapán y dulces, además de miel, conservas, vinos y licores, todo elaborado por monjes y monjas, y listo para degustar en el salón de té. Merece la pena realizar una visita a la tienda aunque sólo sea por respirar su ambiente, además de poder comprar deliciosos artículos de regalo, cuidadosamente empaquetados.

Qui troviamo torte, dolci, marzapane, miele, oltre a conserve, vini e liquori – tutto prodotto da frati e suore. Le delizie si possono assaggiare nella sala da tè situata in cantina. La bottega, che merita senz'altro una visita, propone oggetti da regalo originali e graziosamente impacchettati.

Xocoa

Carrer Vidriería, 4
08003 Barcelona
Ciutat Vella
Phone: +34 / 933 04 03 00
www.xocoa-bcn.com

Opening hours: Mon–Sat 11 am to 10 pm, Sun noon to 3 pm and 4 pm to 10 pm
Products: Chocolate, pralines
Public transportation: Metro Jaume I
Map: No. 59

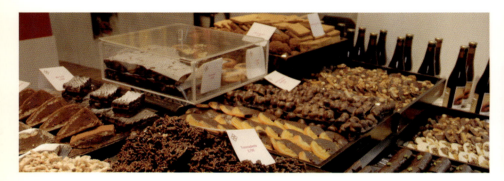

Spicy chocolate with chili, savory with rosemary, sweet with raspberries, plus sinful delights like the almond-crunch coated *Ventall* truffles—almost everything that can be made out of cocoa is available from this family business. You can even have it without calories in the form of shower gel and candles with the scent of chocolate.

Du chocolat épicé au piment, savoureux au romarin ou doux aux framboises, et d'autres péchés mignons comme les truffes *Ventall* enrobées d'amandes croquantes : dans ce commerce familial, vous trouverez presque tout ce qui peut se faire en chocolat. On peut même en trouver sans calories, sous forme de gel douche ou de bougies à la senteur chocolat.

Chocolate negro aromatizado con pimienta o romero, chocolates con frambuesas y auténticas tentaciones como las trufas *Ventell* envueltas en masa de almendras. Todo lo que se pueda crear a partir del cacao puede encontrarse en esta tienda familiar lo presenta, y no sólo en cuanto a las delicias culinarias: también en geles de ducha y velas perfumadas.

Cioccolato piccante al peperoncino, speziato al rosmarino, dolce al gusto di lampone, vere e proprie tentazioni come i *Ventall*, tartufi ricoperti da pasta alle mandorle ... questa azienda a conduzione familiare propone quasi tutto ciò che è possibile produrre con il cacao, addirittura senza calorie: da provare i gel da doccia o le candele al profumo di cioccolato.

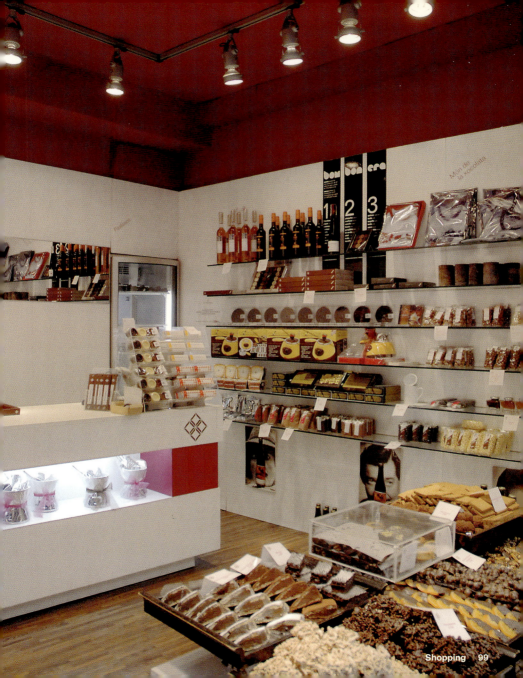

Iguapop Shop

Carrer del Comerç, 15
08003 Barcelona
Ciutat Vella
Phone: +34 / 933 10 07 35
www.iguapop.net

Opening hours: Mon 5 pm to 9 pm, Tue–Sat 11 am to 2.30 pm and 5 pm to 9 pm
Products: Art, fashion
Public transportation: Metro Arc de Triomf, Jaume I
Map: No. 30

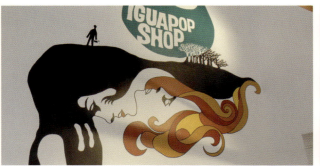

Young artists from Spain and other countries get their chance at the Iguapop gallery, which opened in 2003. It offers graffiti, photography, video art, and installations. Music is part of the concept of the gallery and shop. Accessories for youth culture and fashion for pop culture are also sold in the store.

La galerie Iguapop, qui a ouvert en 2003, donne leur chance à de jeunes artistes d'Espagne et d'ailleurs. Elle expose graffitis, photographies, art vidéo et installations. La musique fait partie du concept de la galerie et de la boutique. Des accessoires de la culture jeune et des vêtements branchés de la culture pop sont également en vente à la boutique.

En la galería Iguapop, abierta en 2003, jóvenes artistas nacionales y extranjeros tienen la oportunidad de darse a conocer, con sus graffitis, fotografías, vídeos e instalaciones. La música forma parte de la idea de la galería y la tienda, que también propone accesorios de cultura juvenil y moda pop.

Aperta nel 2003, la galleria Iguapop vuole essere un'opportunità per giovani artisti nazionali e stranieri. L'esposizione comprende graffiti, fotografie, arte video e installazioni. La musica è in sintonia con quanto offerto dalla galleria e dello shop, che propone anche accessori di cultura giovane e moda pop.

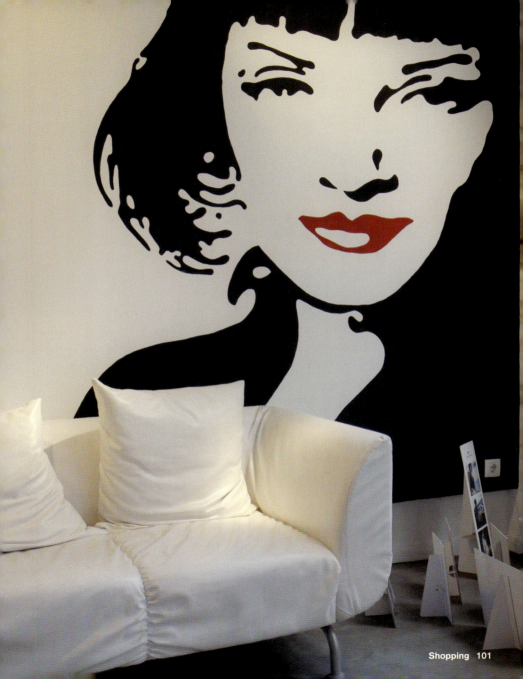

Mercat de la Boqueria

La Rambla, 89
08002 Barcelona
Ciutat Vella
www.boqueria.info

Opening hours: Mon–Sat 8 am to 8.30 pm
Products: Fruits, vegetables, fish, meat, sweets
Public transportation: Metro Liceu
Map: No. 34
Editor's tip: It is essential to try ham, olives and candied fruits.

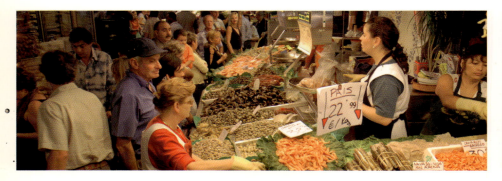

A stroll through the most famous grocery market of Barcelona is an experience, a festival of scents and delicacies: Shellfish and sheep's heads, chocolate and shallots—every fresh product is available here. Many tasty tidbits can also be enjoyed right at the colorful market.

Une balade dans le plus célèbre marché couvert de Barcelone est une véritable expérience, un festival de senteurs et de gourmandise : des coquillages aux têtes de moutons, des chocolats aux échalotes – aucun produit frais ne manque. Ce marché bigarré propose également de nombreux en-cas savoureux.

Una expedición al mercado de alimentación más famoso de Barcelona es una experiencia obligatoria, un banquete de olores y sabores que se entremezclan: marisco y cordero, chocolate y chalota –no hay producto fresco que no se pueda encontrar, y saborear directamente, en este variopinto mercado.

Una visita al più famoso mercato alimentare di Barcellona è un'esperienza che va vissuta, un'orgia di profumi e di prelibatezze: molluschi e tagli d'agnello, cioccolato e cipolle – non c'è prodotto fresco che qui non si possa trovare. Molte delle squisitezze si possono degustare direttamente nel variopinto mercato.

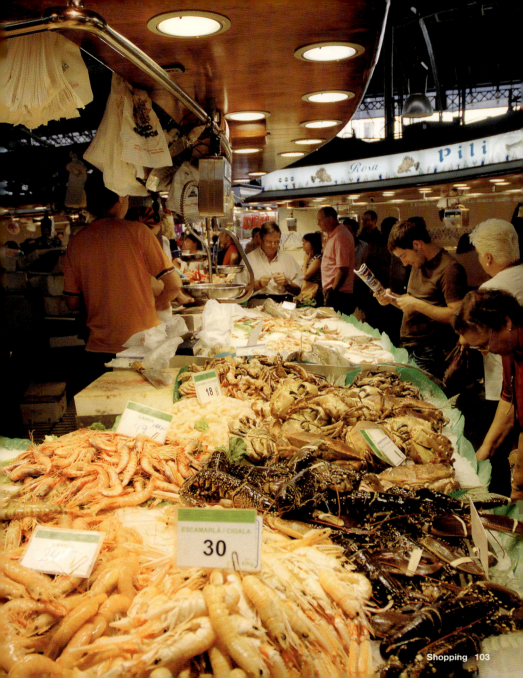

Vila Viniteca

Carrer Agullers, 7–9
08003 Barcelona
El Born
Phone: +34 / 902 32 77 77
www.vilaviniteca.es

Opening hours: Mon–Sat 8.30 am to 8.30 pm
Products: Wines, spirits
Public transportation: Metro Jaume I
Map: No. 57

All the delicious Catalan and Spanish wines in one place: 6 000 varieties—including distinct rarities—as well as cavas, sherries, brandies, and liqueurs are part of the family establishment's assortment. The store is the exclusive distributor for many of the products. Wines can also be tasted in the nearby gourmet department.

Tous les délicieux vins catalans et espagnols réunis en un seul lieu : le catalogue de cet établissement familial compte plus de 6 000 appellations (dont certaines très rares) ainsi que des cavas, xérès, eaux-de-vie et liqueurs. Nombre de ces produits sont vendus exclusivement dans cette boutique. Vous pouvez aussi déguster les vins dans l'espace gourmet attenant.

Los más deliciosos vinos catalanes y españoles reunidos en un mismo lugar: 6 000 variedades —algunas reconocidas como casi únicas— incluyendo cava, jerez, brandy y licores, forman parte de la oferta de la bodega familiar. Muchos de los productos son distribuidos en exclusiva, y todos se pueden degustar en la sección gastronómica.

I più prelibati vini catalani e spagnoli riuniti in un'unica cantina: l'assortimento dell'azienda di famiglia comprende 6 000 nomi, tra cui rarità assolute, e in più Cavas, sherry, brandy e liquori. Molti dei prodotti sono distribuiti in esclusiva. Nella sezione gourmet, situata dirimpetto, è possibile degustare anche vini.

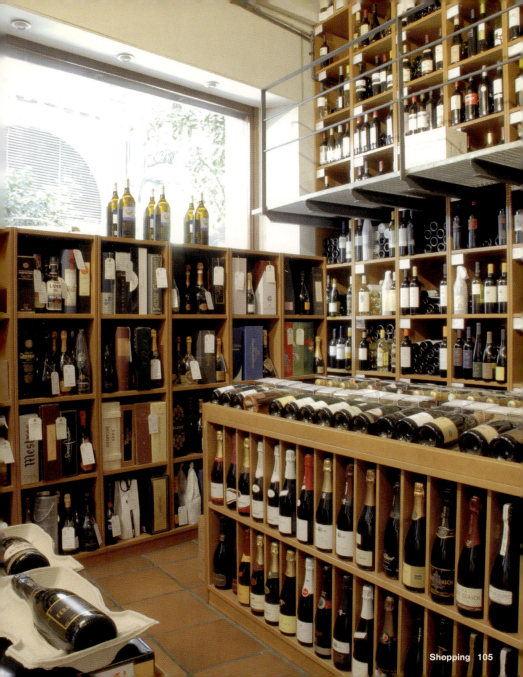

Casa del Llibre

Passeig de Gràcia, 62
08007 Barcelona
Eixample
Phone: +34 / 902 02 64 07
www.casadellibro.com

Opening hours: Mon–Sat 9.30 am to 9.30 pm
Products: Books
Public transportation: Passeig de Gràcia
Map: No. 15

An enormous selection of books from every genre is collected at the Casa del Libre: bestsellers, illustrated books, novels, and self-help books, as well as travel guides. If you are familiar with Spanish or Catalan, you can spend hours leafing and looking. The store also has a small selection of foreign-language books.

La Casa del Libre rassemble une fabuleuse sélection de livres en tous genres : best-sellers, beaux livres, romans et ouvrages de développement personnel côtoient les guides de voyage. Ceux qui comprennent l'espagnol ou le catalan pourront passer des heures à les regarder et à les feuilleter. Le magasin propose également une petite sélection de livres en langues étrangères.

La selección ofrecida por la Casa del Libro es enorme en todos los géneros: bestsellers, libros de fotografía, novelas, ensayos y guías turísticas. Es una invitación a quedarse hurgando y mirando durante horas, y no sólo en castellano o catalán: la Casa presenta también una pequeña selección de libros en otros idiomas.

Propone una scelta vastissima in tutti i generi: best-seller, libri fotografici, narrativa, saggistica e guide turistiche. Chi ha familiarità con lo spagnolo o il catalano può passare delle ore a frugare e sfogliare. La Casa offre inoltre una piccola selezione di libri in lingua straniera.

Passeig de Gràcia

Passeig de Gràcia
08007 Barcelona
Eixample

Public transportation: Metro Diagonal, Passeig de Gràcia and Catalunya
Map: No. 46

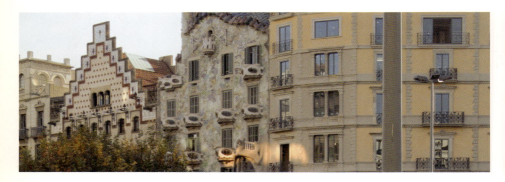

One of the most important splendid boulevards of Barcelona has elegant stores and jewelers, fine hotels and restaurants, as well as impressive traces of *Modernisme*: Magnificent buildings line the 1-mile long boulevard that has street lamps and paving stones with their Catalan art-nouveau ornaments.

Ce splendide boulevard, l'un des plus importants de Barcelone, comporte des boutiques élégantes, des joailleries, de beaux hôtels et des restaurants, ainsi que d'impressionnants souvenirs du *Modernisme* : de magnifiques bâtiments s'alignent sur cette artère longue d'un kilomètre et demi, aux réverbères et aux pavés décorés dans le style art nouveau catalan.

En la calle más representativa del lujo barcelonés podemos encontrar elegantes tiendas y joyerías, nobles hoteles y restaurantes, e impresionantes huellas del modernismo: magníficos edificios bordean la avenida de kilómetro y medio, además de las farolas y los adoquines adornados según el modernismo catalán.

Sulla via elegante più importante di Barcellona si trovano eleganti boutique e gioiellerie, lussuosi hotel e ristoranti, nonché importanti tracce del *modernismo*: magnifici edifici fiancheggiano il viale, lungo un chilometro e mezzo, abbellito da lampioni e selciato tra cui fanno spicco elementi nell'Art Nouveau catalana.

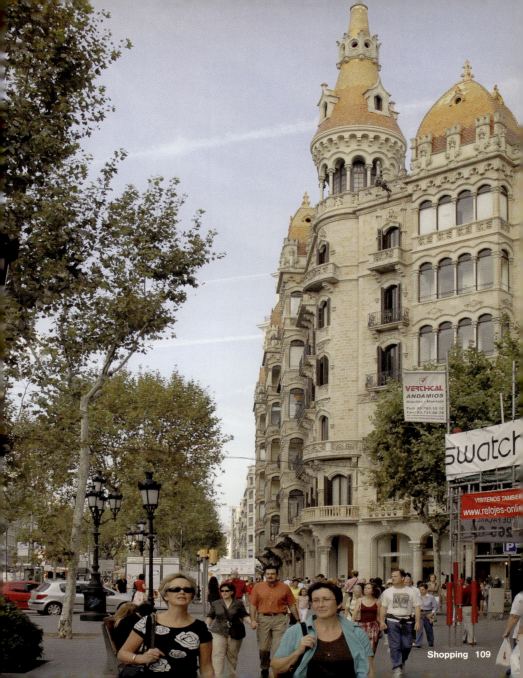

Vinçon

Passeig de Gràcia, 96
08008 Barcelona
Eixample
Phone: +34 / 932 15 60 50
www.vincon.com

Opening hours: Mon–Sat 10 am to 8.30 pm
Products: Design furniture, furnishing accessories
Public transportation: Metro Passeig de Gràcia
Map: No. 58

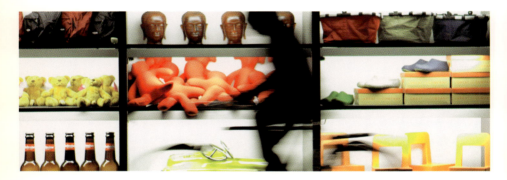

The unique *Modernisme* building on the Passeig de Gràcia houses this design department store with products of contemporary and stylish interior design. You can find the latest and most original home-décor accessories, as well as the design classics. Even the shopping bags have a cult status.

Sur le Passeig de Gràcia, un monument moderniste unique en son genre abrite ce magasin design proposant des objets déco contemporains et stylés. Vous y trouverez aussi bien les derniers accessoires originaux de décoration intérieure que les classiques du design. Même les sacs aux couleurs du magasin sont devenus des articles cultes.

En uno de los edificios modernistas sin igual del Passeig de Gràcia, se encuentra este estudio, con productos centrados en el diseño de interiores contemporáneo. Los más nuevos y originales detalles para la decoración del hogar están representados aquí, junto con los más clásicos. ¡Incluso las bolsas de la compra son piezas de diseño!

Questo magazzino del design si trova in uno degli impareggiabili edifici modernisti sul Passeig de Gràcia: propone prodotti centrati sul disegno contemporaneo e di stile, tra cui i più nuovi e originali dettagli per la decorazione della casa, oltre ai classici del genere. Qui persino le borse per gli acquisti sono un cult.

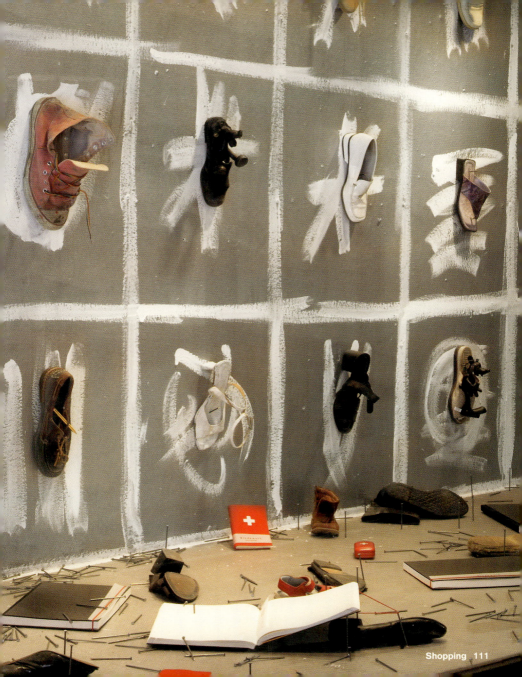

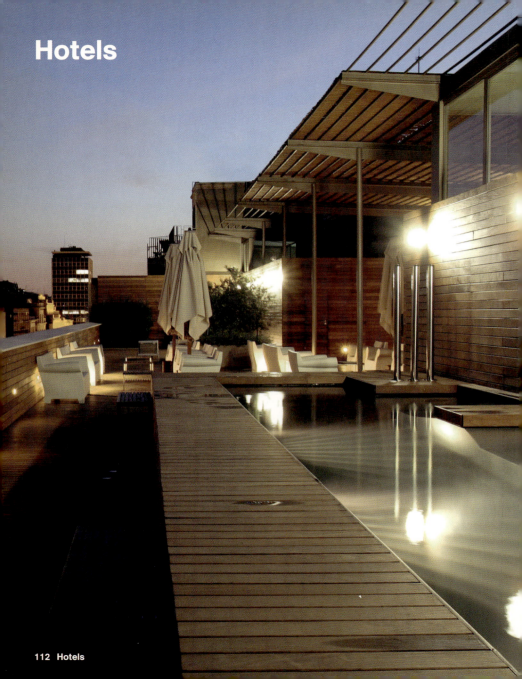
Hotels

Both the selection and the demand are enormous. If you have a specific boutique hotel in mind, be sure to book early. The lovingly designed small hotels—often in beautiful old buildings—are affordable as well. But also the larger establishments—whether the newer luxury palace or the traditional hotel—look like they are local sights. The obligatory roof terrace often offers a wonderful view of the city.

Beaucoup d'offre mais aussi beaucoup de demande : si vous avez un hôtel-boutique spécifique en vue, prenez soin de réserver à l'avance. Les charmants petits hôtels, souvent situés dans de splendides bâtiments anciens, ont aussi l'avantage d'être abordables. Et les plus grands établissements, du palace moderne et luxueux à l'hôtel traditionnel, sont si beaux qu'on a envie de les visiter. Les terrasses sur le toit sont de rigueur, offrant souvent une magnifique vue sur la ville.

Las alternativas son infinitas, la demanda también. Quien se fije en algún hotel boutique, debería reservar a toda prisa. Estos pequeños hoteles, cuidados con cariño, enclavados en preciosos edificios antiguos, suelen ser la opción más adecuada, pero también los grandes hoteles, tradicionales o modernos, tienen su encanto. Las terrazas de los techos, de visita obligatoria, a menudo nos deleitan con fabulosas vistas de la ciudad.

L'offerta è assai vasta, come del resto la domanda. Chi desidera alloggiare in un determinato boutique hotel, deve prenotare per tempo: questi piccoli alberghi, arredati con amore, che si trovano spesso in antichi palazzi, sono anche convenienti. Non mancano tuttavia neanche i grossi hotel, di lusso oppure tradizionali, che sono sovente delle notevoli opere architettoniche. Le obbligatorie terrazze sul tetto offrono spesso una magnifica vista sulla città.

Left page: Hotel Omm
Right page: Left Gran Hotel La Florida, right Pulitzer

 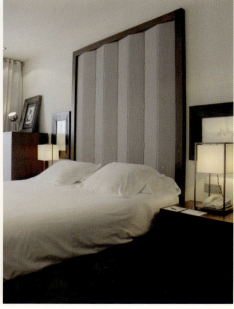

Hotel Arts Barcelona

Carrer de la Marina, 19–21
08005 Barcelona
Ciutat Vella
Phone: +34 / 932 21 10 00
Fax: +34 / 932 21 10 70
www.ritzcarlton.com

Prices: Single and double from € 385, suite from € 500
Facilities: Café, bar, 3 restaurants, Six Senses Spa, outdoor pool and whirlpool
Services: Babysitting, valet parking
Public transportation: Metro Ciutadella Vila Olímpica
Map: No. 28

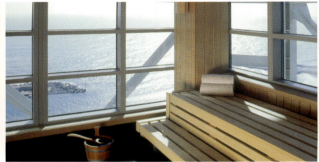

The rooms in the 44-floor tower have very elegant furnishings and offer a view of the Mediterranean and the skyline. Butler service is provided for the apartments on the upper ten floors. Chef Sergi Arola, who has been honored with two Michelin stars, cooks for you. The establishment also offers the Six Senses Spa with an ocean-view sauna.

Les chambres de cette tour de 44 étages sont élégamment meublées et offrent une vue sur la Méditerranée et la silhouette de la ville. Les appartements des dix derniers étages bénéficient d'un service d'étage. Le Chef Sergi Arola, deux étoiles au Guide Michelin, cuisine pour vous. L'établissement comporte également un Six Senses Spa dont le sauna a vue sur la mer.

La decoración de las habitaciones de la torre de 44 plantas es sumamente elegante, con vistas al Mediterráneo y al perfil de la ciudad. En los apartamentos de sus diez plantas superiores se ofrece servicio de habitaciones. El chef es Sergi Arola, premiado con dos estrellas Michelin. Incluye el Six Senses Spa y la sauna con vista al mar.

La camere di questa torre di 44 piani sono arredate in modo assai elegante, con vista sul mediterraneo e sulla skyline. Per gli appartamenti degli ultimi dieci piani è previsto il servizio maggiordomo. Lo chef de cuisine è Sergi Arola, titolare di due stelle Michelin. Il servizio comprende inoltre il Six Senses Spa con sauna con vista sul mare.

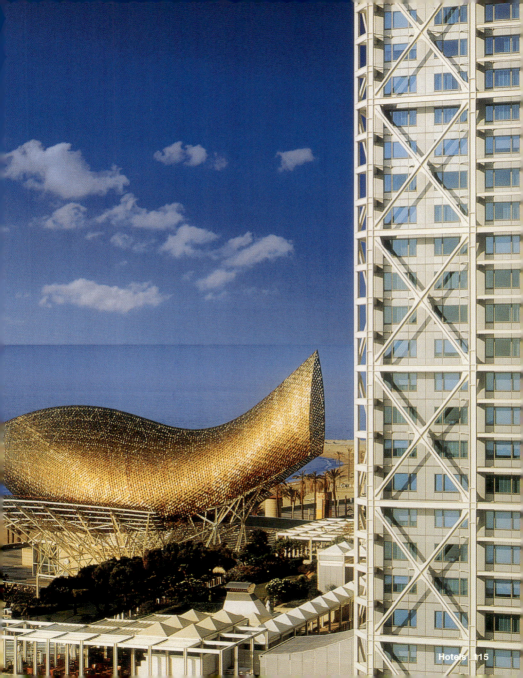

Banys Orientals

Carrer Argenteria, 37
08003 Barcelona
Ciutat Vella
Phone: +34 / 933 42 62 80
Fax: +34 / 933 42 75 63
www.hotelbanysorientals.com

Prices: Single from € 94, double from € 98, suite from € 129
Facilities: Restaurant Senyor Parellada with Catalan cuisine
Public transportation: Metro Jaume I
Map: No. 5

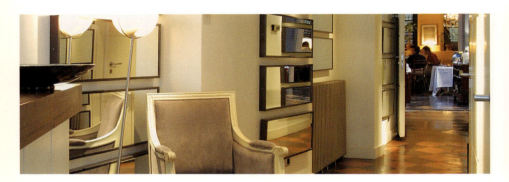

This former manor house from the 19th century has rooms that are furnished in a loving, tasteful, and very modern way with good value for the money. The two-story suites also offer much space. Banys Orientals is a perfect retreat at the center of the lively Born quarter.

Cet ancien manoir du XIXe siècle propose des chambres meublées avec soin et avec goût dans un style moderne, pour un très bon rapport qualité-prix. Les suites en duplex sont également très spacieuses. Le Banys Orientals est un parfait havre de paix au cœur du quartier très animé d'El Born.

En una antigua mansión del siglo XIX, el hotel presenta habitaciones con un gusto exquisito, acogedor y altamente moderno, con una buena relación calidad-precio. Propone también suites de dos plantas, muy espaciosas. En medio del animado barrio del Born, el Banys Orientals es un lugar perfecto para refugiarse.

Questa vecchia casa padronale ottocentesca ha camere modernissime arredate con cura e buon gusto, con un ottimo rapporto qualità-prezzo. Molto spaziose le suite a due piani. Situato in mezzo all'animato quartiere El Born, il Banys Orientals costituisce una perfetta oasi di tranquillità.

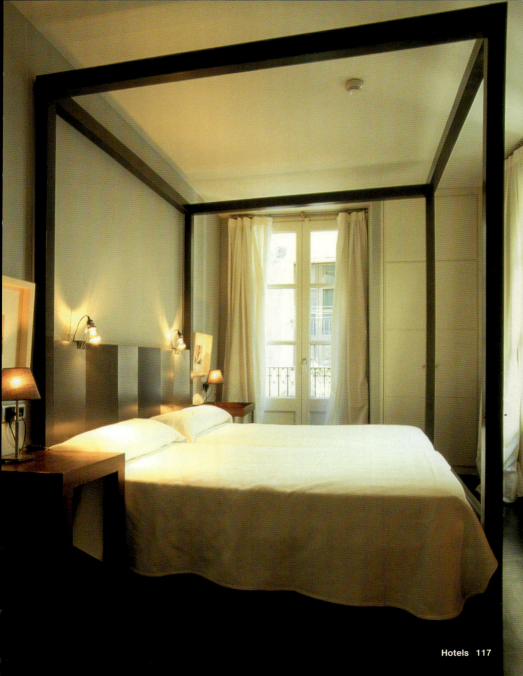

Casa Camper Barcelona

Carrer Elisabets, 11
08001 Barcelona
Ciutat Vella
Phone: +34 / 933 42 62 80
Fax: +34 / 933 42 75 63
www.camper.es

Prices: Single from € 185, double from € 200, suite from € 230
Facilities: Non-smoker rooms and suites
Services: Free breakfast and 24 hours free self service buffet, free Wi-Fi in the entire hotel
Public transportation: Metro Liceu
Map: No. 14
Editor's tip: To explore the city get one of the bicycles provided by the hotel.

The hotel with just 25 rooms is as unconventional as the shoe brand of the same name. The bedroom and living room create a sort of junior suite—for the price of a room. Snacks are available at the buffet day and night. The furnishings of the non-smoker hotel are functional and modern. The food is healthy.

Cet hôtel de seulement 25 chambres est aussi peu conventionnel que la marque de chaussures du même nom. La chambre et le salon forment une sorte de suite junior – pour le prix d'une chambre. Des en-cas sont disponibles au buffet jour et nuit. Cet hôtel non-fumeur est moderne et fonctionnel. Il propose une nourriture saine.

Con sus 25 habitaciones, todas para no fumadores, este hotel en tan poco convencional como la marca de calzado del mismo nombre. Las habitaciones y las salas de estar forman unas mini-suites, al precio de una habitación. El buffet ofrece tapas día y noche, la decoración es funcional y moderna y la comida, sana.

Questo hotel con solo 25 camere è anticonvenzionale quanto l'omonima marca di calzature. La stanza da letto e il salottino formano una sorta di mini-suite al prezzo di una camera. Il buffet propone snack a tutte le ore, l'arredamento è funzionale e moderno, la cucina è sana e il fumo … è proibito.

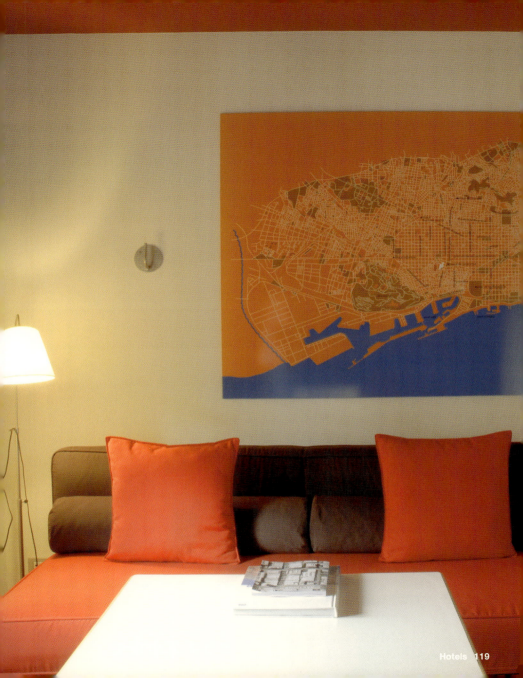

H1898

La Rambla, 109
(Entrance via Carrer Pintor Fortuny)
08002 Barcelona
Ciutat Vella
Phone: +34 / 935 52 95 52
Fax: +34 / 935 52 95 50
www.nnhotels.com

Prices: Single and double from € 165, suite from € 355
Facilities: Some rooms and suites with terrace and own pool, restaurant
Services: Spa for hotel guests free, gym, outdoor pool with tanning booth, spa with swimming pool
Public transportation: Metro Catalunya
Map: No. 26

The façade of this splendid building from the year 1881 conceals a maximum of elegance and luxury that includes colonial accents. The spectrum of amenities ranges from the free Internet access to the spa, swimming pool, and ambitious Mediterranean cuisine to the suite with a private pool and garden.

Derrière la façade de ce magnifique bâtiment de 1881 se cache un trésor d'élégance et de luxe aux accents coloniaux. L'éventail des équipements va de l'accès internet gratuit au spa, en passant par la cuisine méditerranéenne ambitieuse, et la suite avec piscine et jardin privés.

Detrás de la fachada de una magnífica construcción del año 1881 se esconde el máximo de la elegancia y del lujo, con toques coloniales. Desde el acceso gratuito a Internet o el centro spa hasta la ambiciosa cocina mediterránea y las suites con piscina privada y jardín, la gama de las comodidades es prácticamente ilimitada.

Dietro la facciata del magnifico edificio del 1881 si nasconde il massimo dell'eleganza e del lusso, con accenti coloniali. Il ventaglio delle comodità spazia dall'accesso gratuito a Internet al centro termale, dalla ricercata cucina mediterranea alla suite con piscina e giardino privati.

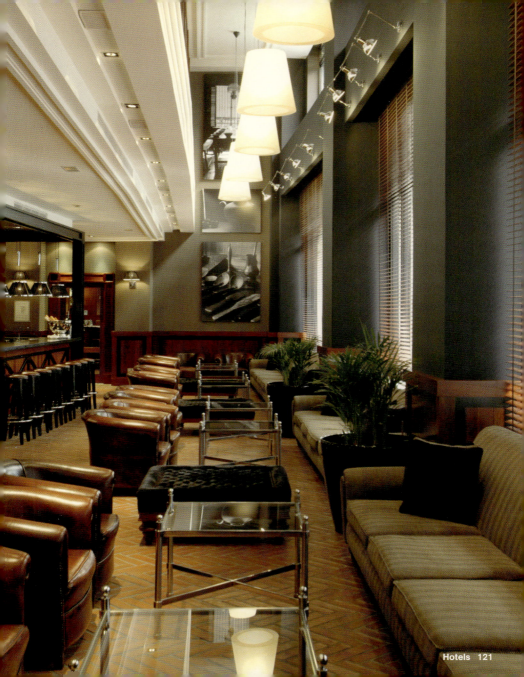

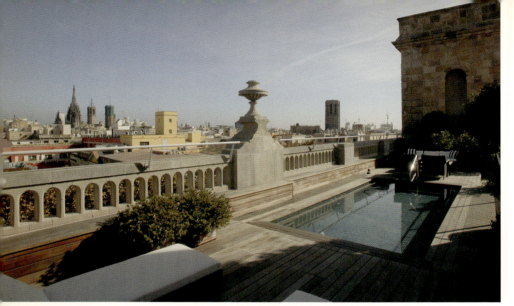
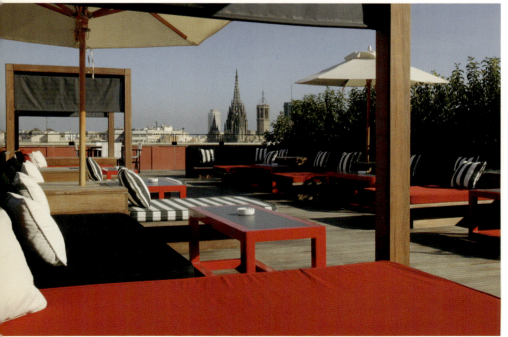

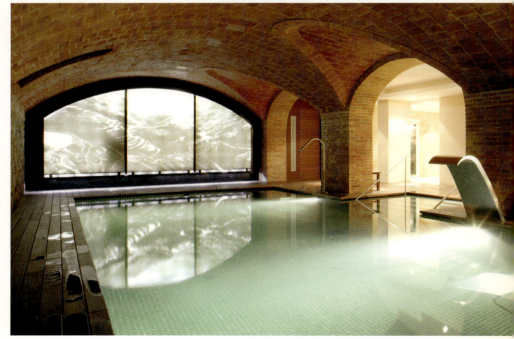

Neri Hotel & Restaurante

Carrer de Sant Sever, 5
08002 Barcelona
Ciutat Vella
Phone: +34 / 933 04 06 55
Fax: +34 / 933 04 03 37
www.hotelneri.com

Prices: Single and double from € 295 exclusive breakfast
Facilities: All rooms have internet access, restaurant, bar, rooftop terrace with deck chairs and shower
Public transportation: Metro Jaume I
Map: No. 41

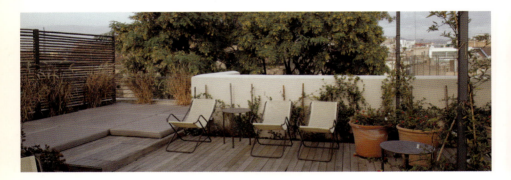

Situated in a lovingly restored palace from the 18th century, the 22 rooms of this hotel have antiques and very modern furniture—and high-tech equipment. Large-size pictures hang over the beds. Jordi Ruiz cooks Mediterranean specialties with Arabian influences.

Situées dans un charmant palais restauré du XVIIIe siècle, les 22 chambres de cet hôtel marient antiquités et meubles contemporains, et offrent des prestations high-tech. De grands tableaux sont accrochés au-dessus des lits. Dans le restaurant, Jordi Ruiz cuisine des spécialités méditerranéennes aux influences arabes.

Ubicado en un palacete del siglo XVIII, cuidadosamente renovado, en sus 22 habitaciones el hotel ofrece tanto antigüedades como una decoración totalmente moderna, con equipos de alta tecnología. Sobre las camas cuelgan cuadros de gran formato. El chef Jordi Ruiz propone especialidades mediterráneas con influencias árabes.

All'interno di un palazzo del secolo XVIII accuratamente restaurato, le 22 camere di questo hotel alternano pezzi d'antiquariato e mobili assai moderni, con arredamento high-tech. Sui letti sono appesi quadri di grande formato. Al ristorante, Jordi Ruiz propone specialità mediterranee con influssi arabi.

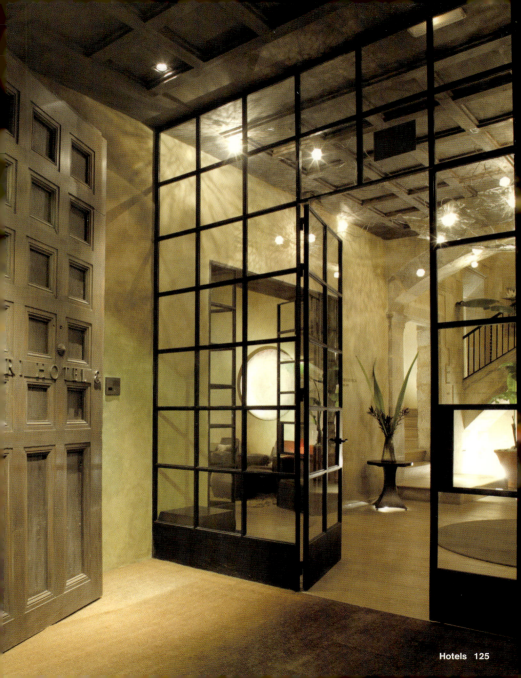

Axel Hotel Barcelona

Carrer d'Aribau, 33
08011 Barcelona
Eixample
Phone: +34 / 933 23 93 93
Fax: +34 / 933 23 93 94
www.axelhotels.com

Prices: Single from € 89, double from € 137, suite from € 279
Facilities: Restaurant, bar & chill out, Sky Bar (May to Oct), swimming pool on the rooftop terrace
Services: Sauna, Jacuzzi, massage, library and business center
Public transportation: Metro Universitat and Passeig de Gràcia
Map: No. 4
Editor's tip: On Thu during dinner drag queens perform at the Shimai show.

The favorite hotel of gay Barcelona fans is crowned by a beautiful roof terrace with a swimming pool, bar, spa, and an outstanding restaurant. The rooms are functionally furnished in a light color scheme, and many of them have a balcony. It goes without saying that the centrally located building also welcomes heterosexual guests.

L'hôtel préféré de la communauté gay à Barcelone est surmonté d'une magnifique terrasse avec piscine, bar, spa et un fantastique restaurant. Les chambres dans les tons pastel sont meublées de manière fonctionnelle, et plusieurs disposent d'un balcon. Il va sans dire que cet établissement du centre ville accueille également les hôtes hétérosexuels.

Situado en el enclave céntrico, y lugar favorito para la comunidad homosexual de Barcelona, el hotel es coronado por una hermosa terraza en su techo, con piscina, spa, y un magnífico restaurante. Las habitaciones son luminosas y funcionales, y muchas tienen un amplio balcón. Obviamente, la clientela heterosexual también es bienvenida.

Meta prediletta dalla comunità omosessuale di Barcellona, l'Axel culmina in una bella terrazza con piscina, bar e centro benessere, nonché in un eccellente ristorante. Le camere sono luminose e funzionali, molte con balcone. Nell'hotel, situato in pieno centro, è naturalmente benvenuta anche la clientela eterosessuale.

Granados 83

Carrer d'ENoic Granados, 83
08008 Barcelona
Eixample
Phone: +34 / 934 92 96 70
Fax: +34 / 934 92 96 90
www.derbyhotels.com

Prices: Single from € 168, double from € 246
Facilities: Some rooms are on 3 stories, semi-private swimming pool and terrace in the duplex suites, 2 restaurants and bars, rooftop terrace with swimming pool
Services: Free entry to the Barcelona Egyptian Museum, Mercedes Smart courtesy car
Public transportation: Metro Diagonal and Passeig de Gràcia
Map: No. 25

The hotel in art deco style is located in the walls of a former hospital, but this is not evident in the minimalist-elegant interior. The 77 rooms are predominantly furnished with fine materials and high-tech equipment. Asian artwork complements the design of Granados 83, which is oriented upon the principles of Zen.

Cet hôtel au style art déco est aménagé dans un ancien hôpital, ce qui n'est pas évident au vu de sa décoration à l'élégance minimaliste. Les 77 chambres, meublées de matériaux nobles, offrent un équipement ultra-moderne. Des œuvres asiatiques complètent le décor du Granados 83, aménagé selon les principes du zen.

Este hotel, en estilo art-déco, está ubicado en el interior de un antiguo hospital, y presenta una decoración minimalista y elegante. En sus 77 habitaciones, equipadas con alta tecnología, dominan los materiales nobles. Obras de arte asiático, de diseño inspirado por principios Zen, complementan la decoración.

Grazie all'arredamento elegante-minimalista di questo hotel in stile art déco, si stenta a credere che esso si trovi all'interno di un ex ospedale. Nelle 77 camere, provviste delle ultime tecnologie, prevalgono materiali nobili. Opere d'arte dal sapore orientale integrano il design ispirato ai princìpi Zen.

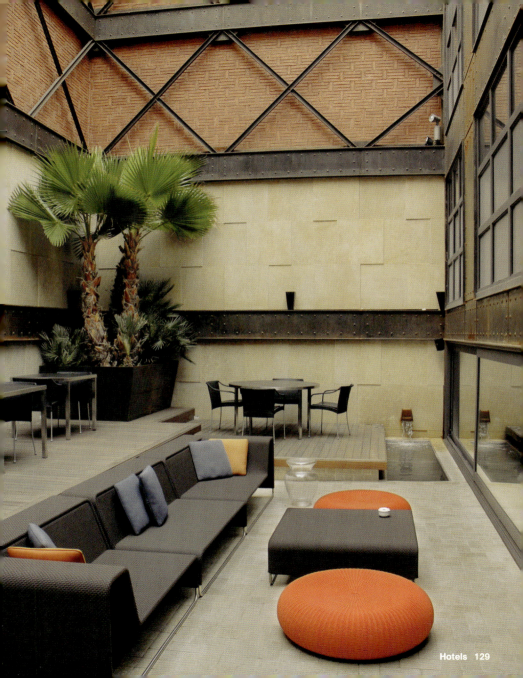

Market Hotel

Passatge de Sant Antoni
Abat, 10
08015 Barcelona
Eixample
Phone: +34 / 933 25 12 05
Fax: +34 / 934 24 29 65
www.markethotel.com.es

Prices: Single from € 75, double from € 88, junior suite from € 105, apartment from € 120
Facilities: Restaurant
Services: Free Wi-Fi in all rooms and the restaurant, free notebook rental, bicycle rental
Public transportation: Metro Sant Antoni and Urgell
Map: No. 33

This hotel in Eixample is bright, modern, and friendly—at very moderate prices. The restaurant offers respectable Mediterranean food in a cultivated ambience. Clear lines, the colors black, white, and red, as well as concentration on what is essential characterize the rooms and give the building a touch of the Far East.

Cet hôtel de l'Eixample est lumineux, moderne et accueillant – pour un prix très modéré. Le restaurant propose une très bonne cuisine méditerranéenne dans une ambiance raffinée. Lignes claires, simplicité des couleurs : noir, blanc et rouge, et minimalisme caractérisent les chambres et donnent à l'établissement un cachet extrême-oriental.

Este hotel del Eixample es luminoso, moderno y acogedor, con unos precios muy razonables. El restaurante ofrece comida mediterránea con sustancia, en un ambiente bien cuidado. Líneas claras en negro, blanco y rojo y una atención a lo esencial, caracterizan a las habitaciones y confieren al Market un aire ligeramente asiático.

Situato nell'Eixample, il Market è luminoso, moderno e accogliente – a prezzi molto moderati. Il ristorante propone sostanziosa cucina mediterranea in un ambiente ben curato. Linee definite in nero-bianco-rosso e ricerca dell'essenzialità caratterizzano l'arredamento delle camere, dal vago sapore orientale.

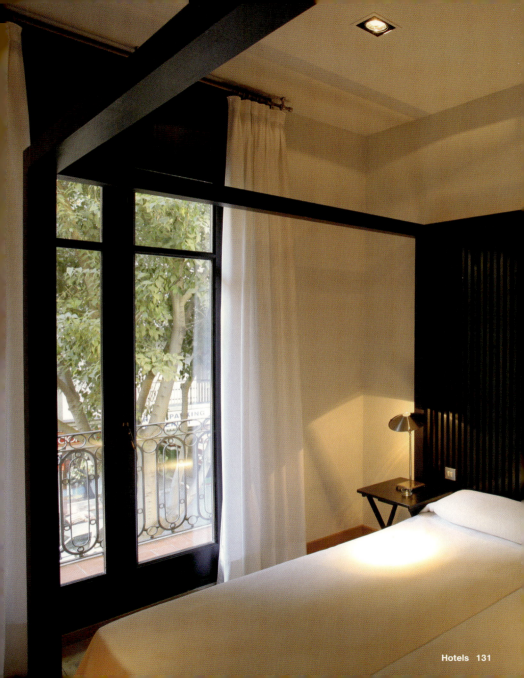

Hotel Omm

Carrer del Rosselló, 265
08008 Barcelona
Eixample
Phone: +34 / 934 45 40 00
Fax: +34 / 934 45 40 04
www.hotelomm.es

Prices: Single room and double room from € 230, breakfast buffet € 21
Facilities: 2 restaurants, Omm Session Club, rooftop terrace with outdoor pool
Services: Spa, restaurant Movida daily 1.30 pm to 1 am, Omm Session Club Wed–Sat 11.30 pm to 3.30 pm
Public transportation: Metro Diagonal
Map: No. 29

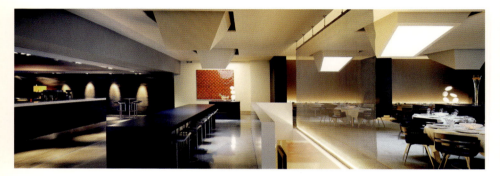

Instead of a traditional lobby und reception desk, there is a large, indirectly illuminated hall with sofas, a fireplace, and bar tables. The hotel has 91 rooms in a light color scheme. One of the best restaurants in the city is the "Moo"—and the spa, which is even open to people who are not guests, is also spectacular. There is a tempting terrace with a bar and a pool on the roof.

Cet hôtel a remplacé le guichet et le hall traditionnels par un vaste salon aux lumières tamisées, avec des canapés, une cheminée et des tables de bar. Il possède 91 chambres très lumineuses. L'une des meilleures adresses de la ville sont le restaurant « Moo » — et le spa, qui n'est pas seulement réservé aux clients de l'établissement. La terrasse sur le toit, avec son bar et sa piscine, est très tentante.

El hotel incluye 91 habitaciones, y en lugar de la recepción tradicional, presenta una amplia sala iluminada indirectamente, con sofás, una chimeneta y mesas de bar. El restaurante "Moo" es uno de los más apreciados de la ciudad, como su centro spa, abierto a huéspedes y externos. En el tejado, encontramos la terraza con bar y piscina.

L'atrio e la reception tradizionali sono qui sostituiti da un'ampia sala con illuminazione indiretta, divani, caminetto e tavolini. L'albergo comprende 91 luminose camere. Il ristorante "Moo" è considerato tra i migliori in città, così come il centro benessere, aperto anche ai non ospiti. Sul tetto c'è una terrazza con bar e piscina.

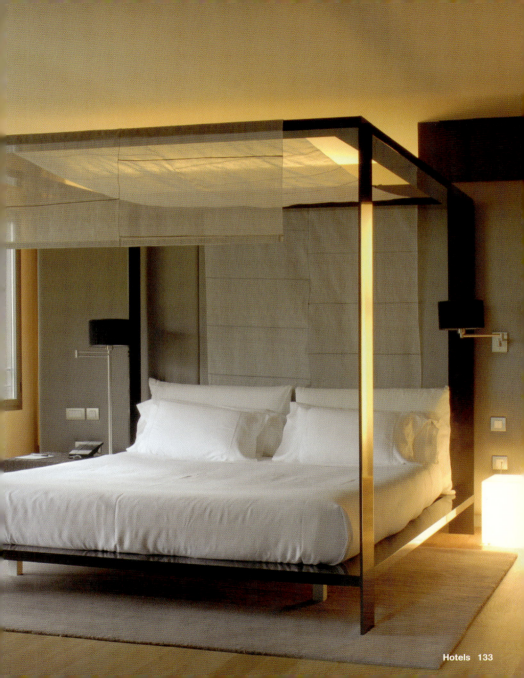

Pulitzer

Carrer Bergara, 8
08002 Barcelona
Eixample
Phone: +34 / 934 81 67 67
Fax: +34 / 934 81 64 64
www.hotelpulitzer.es

Prices: Single room from € 120, double room from € 120, suite from € 400
Facilities: Restaurant, rooftop terrace with a summer bar, library
Services: 2 non-smoker stories
Public transportation: Metro Catalunya
Map: No. 50
Editor's tip: Free access to Holmes Place, a nearby gym.

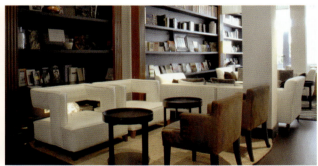

Abstract paintings, modern art objects, and tasteful furniture give this boutique hotel with its 91 elegant rooms a special touch. The view from the bar on the roof terrace is toward the Rambles and the Gothic quarter. The restaurant is excellent, and nightlife pulsates right in front of the door.

Tableaux abstraits, objets d'art moderne et meubles choisis avec goût confèrent un cachet particulier à cet hôtel-boutique aux 91 chambres élégantes. Le bar de la terrasse, sur le toit, domine les Rambles et le quartier Gothique. Le restaurant est excellent et la vie nocturne bat son plein juste en face.

Pinturas abstractas, objetos de arte moderno y muebles de un gusto exquisito otorgan un toque especial a este hotel boutique con sus 91 habitaciones. Desde el bar de la terraza de la última planta, la vista llega hasta las Ramblas y el Barrio Gótico. El restaurante es excelente, y la vida nocturna barcelonesa está justo al lado.

Dipinti astratti, oggetti d'arte moderna e arredamento di ottimo gusto conferiscono un tocco speciale a questo boutique hotel, che comprende 91 eleganti camere. Dal bar sulla terrazza la vista spazia sulle Ramblas e sul Quartiere Gotico. Il ristorante è ottimo e la vita notturna della città pulsa appena fuori della porta.

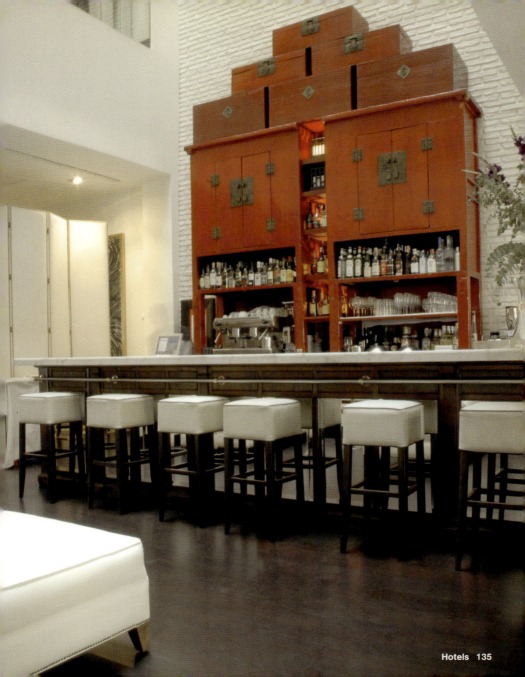

Gran Hotel La Florida

Carretera Vallvidrera al
Tibidabo, 83–93
08035 Barcelona
Horta Guinarda / Sarrià-Sant Gervasi
Phone: +34 / 932 59 30 00
Fax: +34 / 932 59 30 01
www.hotellaflorida.com

Prices: Single, double and suite from € 250
Facilities: 22 designer suites
Services: ZenZone spa with and indoor and outdoor swimming pool, massage, free shuttle service between the hotel and the city center daily between 10 am and 6 pm
Map: No. 23

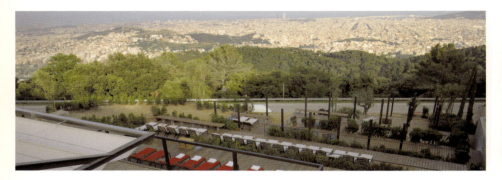

This luxury hotel, which opened its doors in 1925 in the hills of Collserola with a fantastic view of Barcelona and the Mediterranean, has an interior adorned with works by international artists. Celebrities visited the hotel in the 1950s. In addition to the luxuriant gardens, the gourmet restaurant, the nightclub, and the spa, the 74 magnificent rooms and suites delight visitors.

Fundado en 1925, en el alto de Collserola, con una panorámica fantástica sobre la ciudad y el Mediterráneo, el Gran Hotel está adornado por obras de artistas internacionales y sus 74 magníficas habitaciones y suites fueron frecuentadas por famosos en los años 50. Presenta, además, un lujoso jardín, un refinado restaurante, un club nocturno y un centro spa.

Ce luxueux hôtel, qui a ouvert ses portes en 1925 sur les collines de Collserola, offre une vue fantastique sur Barcelone et la Méditerranée. L'intérieur est décoré d'oeuvres d'artistes internationaux. Dans les années 50, des célébrités séjournaient ici. Ses jardins luxuriants, son restaurant gastronomique, son night-club, son spa, et bien entendu ses 74 magnifiques chambres et suites enchantent les visiteurs.

Opere di artisti internazionali impreziosiscono gli interni di questo Grand Hotel, aperto nel 1925 e situato sul Collserola, da cui si gode una splendida vista su Barcellona e sul Mediterraneo. L'hotel, che negli anni '50 era frequentato da celebrità, dispone di 74 sontuose camere e suite, oltre ad un rigoglioso giardino, un ristorante da gourmet, un nightclub e un centro benessere.

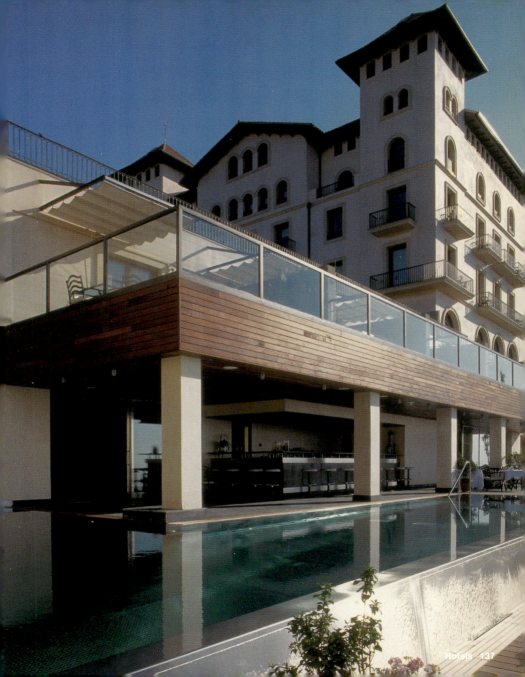

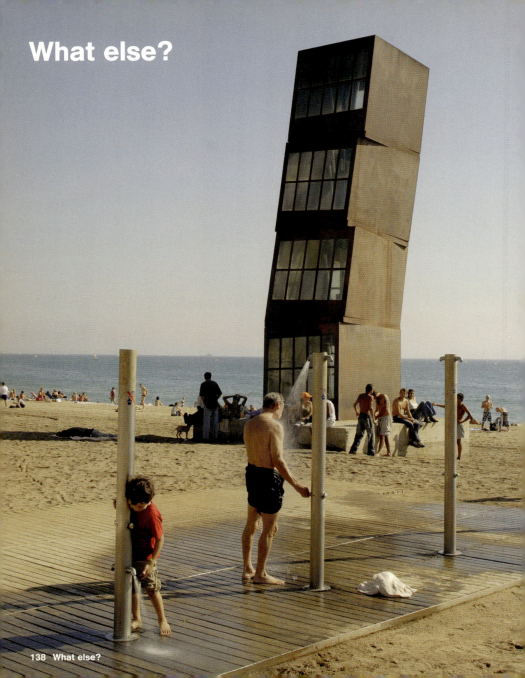

What else?

If you have seen the most important museums, churches, and other buildings, then you deserve some relaxation. Be sure to stroll through the streets, sit in the café, look at the ocean, or relax in a spa. Fashion-victims will be drawn to the Museu Tèxtil i d'Indumentària. If you would like to do something outside of the city, you can trek to the Teatre-Museu Dalí in Figueres or to Montserrat, the second-most important place of pilgrimage in Spain.

Si vous avez visité les principaux musées, églises et bâtiments, vous méritez un peu de détente. N'oubliez pas de déambuler dans les rues, de vous asseoir dans les cafés, de contempler la mer ou de vous relaxer dans un spa. Les « fashion victims » feront un détour par le Museu Tèxtil i d'Indumentària. Si vous voulez sortir de la ville, vous pouvez partir en excursion au Teatre-Museu Dalí à Figueres, ou à Montserrat, le deuxième site de pèlerinage d'Espagne.

Tras visitar los importantes museos, iglesias y construcciones, podemos pasear por las calles, sentarnos en un café, mirar al mar o relajarnos en algún spa. Las "víctimas de la moda" pueden visitar el Museu Tèxtil i d'Indumentària, y quien quiera salir de la ciudad puede desplazarse hasta el Teatre-Museu Dalí de Figueres o hasta el santuario de Montserrat, segundo lugar más importante de peregrinaje en España.

Dopo aver visitato i musei, le chiese e i palazzi più importanti, possiamo concederci un po' di relax passeggiando per la città o sedendoci in qualche caffè di fronte al mare, oppure in un centro termale. I patiti della moda possono visitare il Museu Tèxtil i d'Indumentària. Per chi volesse uscire dalla città, segnaliamo il Teatre-Museu Dalí a Figueres o il santuario di Montserrat, seconda meta di pellegrinaggio per importanza in Spagna.

Left page: Platja Barceloneta, **right page:** Left Casa Batlló, right Parc de L'Espanya Industrial

L'Aquàrium de Barcelona

Moll d'Espanya del Port Vell, s/n
08039 Barcelona
Ciutat Vella
Phone: +34 / 932 21 74 74
www.aquariumbcn.com

Opening hours: All year round daily from 9.30 am, Mon–Fri to 9 pm, Sat, Sun and legal holidays in June and Sept to 9.30 pm, July and Aug to 11 pm
Prices: Adults € 15.50, senior citizens (60 and over) € 12.50, children 4 to 12 years € 10.50
Public transportation: Metro, bus Drassanes
Map: No. 3

With 11,000 marine animals and 450 species, as well as 35 pools, this is one of the largest aquariums in the world. Visitors with a certificate can even dive with the sharks. Others can ride through the shark pool on the walkway of a 260-ft long glass tunnel. There is also an interactive exhibit on ecosystems.

Avec ses 11 000 animaux marins appartenant à 450 espèces, et ses 35 bassins, c'est un des plus grands aquariums au monde. Les visiteurs titulaires d'un brevet peuvent même plonger avec les requins. Les autres contempleront le bassin des requins sur un tapis roulant à l'intérieur d'un tunnel de verre de 80 m de long. Une exposition interactive sur les écosystèmes y est également présentée.

Con sus 11 000 animales marinos de 450 especies y sus 35 piscinas, el Aquàrium es uno de los más grandes del mundo. Los visitantes autorizados incluso pueden bucear con los tiburones ... los demás pueden desplazarse por el túnel de cristal que recorre las piscinas, largo 80 m. También incluye una exposición interactiva sobre el ecosistema.

Con 11 000 animali marini e 450 specie diverse, nonchè 35 vasche, l'Aquàrium è uno dei più grandi al mondo. I visitatori autorizzati possono addirittura tuffarsi tra gli squali. Gli altri si lasciano trasportare dal tapin roulant all'interno del tunnel di vetro di 80 m che passa in mezzo alle vasche. C'è anche un'esposizione interattiva sull'ecosistema.

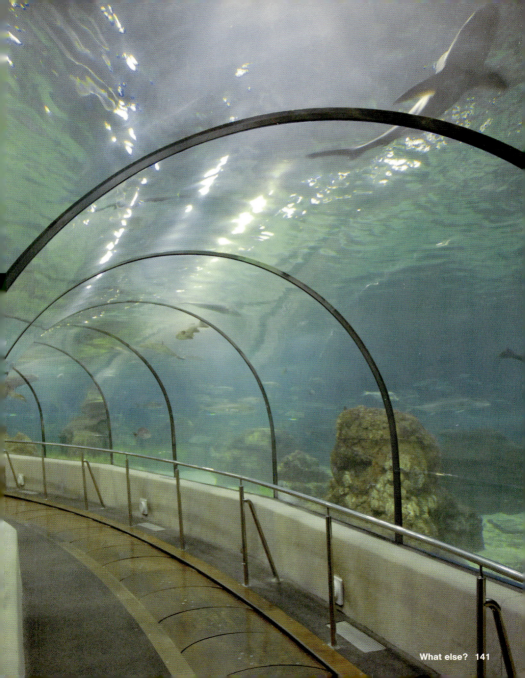

Harbor Tour in the Golondrinas

Portal de la Pau
Monument a Colom
Rambla del Mar
Ciutat Vella
Phone: +34 / 934 42 31 06
www.lasgolondrinas.com

Opening hours: Short tour (35 mins) July–Sept daily 11.45 am to 7 pm, every 35 mins, Oct–15th Dec Mon–Fri 11.45 am to 5 pm every hour, Sat, Sun and legal holidays 11.35 am to 4 pm, every 35 mins, long tour (1.5 hours) daily 11.30 am, 12.30 pm, 1.30 pm, 3.30 pm and 4.30 pm
Prices: Long tour (1.5 hours) adults € 10.50, children € 4.80, short tour (35 mins) adults 5 €, children € 2.50
Public transportation: Metro Drassanes
Map: No. 27

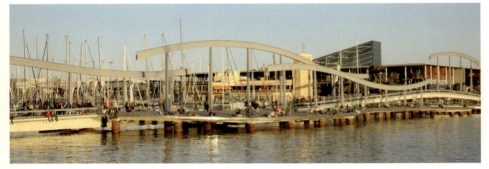

One of the best views of the city is available on board the *Golondrinas*, the little launches that have offered harbor tours since 1888. In addition to the route to Port Olímpic, you can ride to Rompeolas, the outer edge of the harbor basin. A third route connects the Old Harbor with Port Forum.

C'est à bord des *Golondrinas*, ces petits bateaux qui proposent des tours du port depuis 1888, que l'on jouit d'une des plus belles vues sur la ville. Un circuit mène jusqu'au Port Olímpic, un autre jusqu'à Rompeolas, à la bordure extérieure du bassin portuaire. Un troisième relie le Vieux Port au Port Forum.

Una de las más bonitas perspectivas de la ciudad se disfruta desde las Golondrinas, las pequeñas lanchas que desde 1888 ofrecen recorridos panorámicos. Podemos optar por viajar hacia el Puerto Olímpico o hacia el Rompeolas, el límite exterior del dique. Una tercera ruta conecta el Puerto Viejo con el Port Fòrum.

Una delle più belle prospettive della città si apprezza a bordo delle *Golondrinas*, le piccole lance che dal 1888 offrono un giro panoramico del porto. A scelta, si può arrivare fino al Porto Olimpico oppure fino ai Rompeolas, che costituiscono il limite esterno del bacino portuale. Un terzo itinerario unisce il Porto Vecchio al Port Forum.

Jardí Botànic de Barcelona

Carrer del Dr. Font i Quer, 2
Parc de Montjuïc
08038 Barcelona
Sants-Montjuïc
Phone: +34 / 934 26 49 35
www.jardibotanic.bcn.cat

Opening hours: April–June and Sept Mon–Fri 10 am to 5 pm, Sat, Sun and legal holidays 10 am to 8 pm, July+Aug Mon–Sun 10 am to 8 pm, Oct–March Mon–Sun 10 am to 5 pm
Prices: Adults € 3, children (16 and under) and last Sun of each month free
Public transportation: Bus Parc de Montjuïc
Map: No. 31

All of the Mediterranean vegetation regions of the world are replicated in a faithful reproduction on 34 acres: In addition to the flora of the Mediterranean area, the typical plants of California, Chile, Australia, South Africa, the Canary Islands, and North Africa are found here. The view of Barcelona from the garden is also magnificent.

Toutes les zones de végétation méditerranéenne au monde sont fidèlement reproduites sur 14 ha : outre la flore méditerranéenne, on y trouve toutes les plantes typiques de Californie, du Chili, d'Australie, d'Afrique du Sud, des Iles Canaries et d'Afrique du Nord. On y a également une magnifique vue sur Barcelone.

Todas las zonas naturales del Mediterráneo se reconstruyen en un área de 14 ha, con ambientes fieles a los originales. Además es posible admirar plantas oriundas de California, Chile, Australia, Sudáfrica, así como de Canarias y del Norte de África. Una vez más, la vista sobre Barcelona es grandiosa.

Tutte le tipologie di vegetazione mediterranea sono fedelmente riprodotte su un'area di 14 ha. Oltre alla flora del Mediterraneo vero e proprio, si trovano piante tipiche della California, del Cile, dell'Australia, del Sudafrica, delle Canarie e dell'Africa settentrionale. Anche da qui si gode una magnifica vista della città.

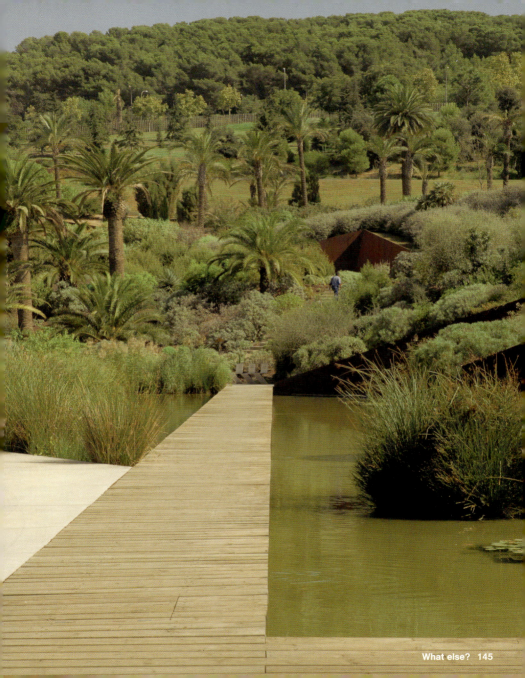

Transbordador Aeri del Port

Passeig de Joan de Borbó, 88
Torre de Sant Sebastià
08003 Barcelona
Les Corts
Phone: +34 / 934 30 47 16

Opening hours: Jan—28. Feb daily 10.30 am to 5.45 pm, March—10th June 10.45 am to 7 pm, 11th June—16th Sept 11 am to 8 pm, 17th Sept—21st Oct 10.45 am to 7 pm, 22nd Oct—31st Dec 10.30 am to 5.45 pm
Prices: Single € 9, return € 12.50
Public transportation: Metro Barceloneta (Torre de Sant Sebastià 56a), Metro Drassanes (Torre de Jaume I 56b), Metro Paral•lel, continuation with Funicular to Montjuïc (Zona Miramar 56c)
Map: No. 56a–c

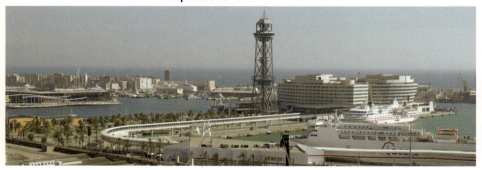

A cable railway glides above the harbor to the city's local mountain—the panorama during the trip is tremendous. The Montjuïc is the green lung of Barcelona and a true leisure-time paradise with dreamy gardens and various attractions like the Olympic Ring, Castell de Montjuïc, and the National Palace.

Un funiculaire relie le port à la colline locale : le paysage que l'on découvre pendant le trajet est fantastique. Montjuïc est le poumon vert de Barcelone, et c'est un vrai paradis pour les loisirs avec ses jardins romantiques et ses diverses attractions comme le Parc Olympique, le Castell de Montjuïc et le Palais National.

Por encima del puerto un funicular atraviesa la ciudad, llegando hasta la montaña que la domina. El panorama desde el recorrido es magnífico. El Montjuïc es el pulmón verde de Barcelona, y un auténtico paraíso del tiempo libre, con jardines de ensueño y varias atracciones como la zona Olímpica, el Castell de Montjuïc o el Palacio Nacional.

Sopra al porto corre una funivia che porta alla montagna che domina la città: la vista durante il viaggio è eccezionale. Il Montjuïc è il polmone verde di Barcellona, un autentico paradiso del tempo libero, con giardini da sogno e diverse attrazioni tra cui il villaggio olimpico, il Castell de Montjuïc e il Palazzo Nazionale.

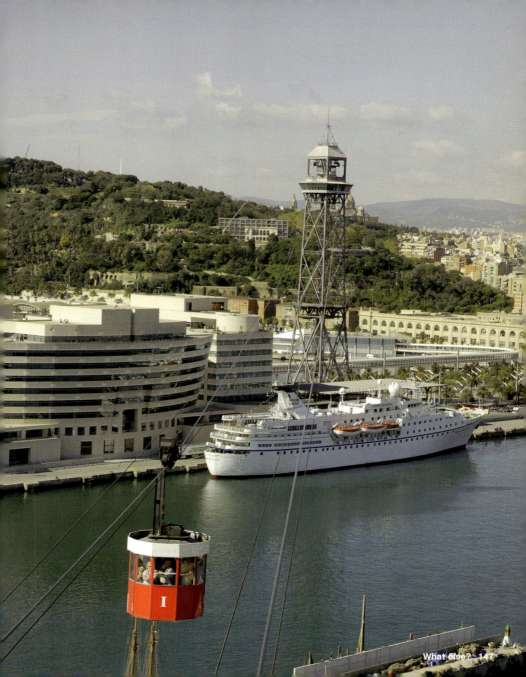

Municipal Beaches: Platja de la Barceloneta, Platja Nova Icària, Platja del Bogatell

From Port Vell (Ciutat Vella) to approx. Forum Barcelona 2004 (Sant Martí)
www.bcn.es/parcsijardins/homeplatges.htm

Public transportation for Platja de la Barceloneta: Metro Barceloneta
Public transportation for Platja Nova Icària: Metro Ciutadella Vila Olímpica
Public transportation for Platja del Bogatell: Metro Poblenou and Llacuna
Map: No. 36a–c

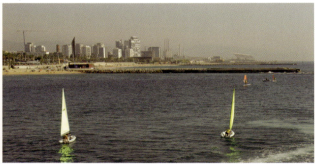

The perfectly maintained city beaches have a total length of 3 m. Barcelona's own beach is Platja de la Barceloneta. Platja Nova Icària close to Port Olímpic is rather small—but offers nice bars and restaurants. Cyclists, joggers, and inline skaters meet on the promenade of Bogatell beach.

Les plages parfaitement entrenues s'étendent sur une longueur totale de 5 km. La Platja de la Barceloneta est la plage de la ville. La Platja Nova Icària, près du Port Olímpic, est plutôt petite, mais regorge de bars et restaurants sympathiques. Les cyclistes, les joggers, et les adeptes du roller en ligne se rencontrent sur la promenade de la plage de Bogatell.

Cuidadas de manera impecable, las playas miden 5 km en su totalidad. La Platja de la Barceloneta es la playa de los barceloneses, Nova Icària está cerca del Puerto Olímpico y quizás tenga menos encanto, sin embargo, ofrece bonitos bares y restaurantes. El paseo del Bogatell es muy frecuentado por paseantes, ciclistas y patinadores.

Le spiagge, curate in modo impeccabile, hanno una lunghezza complessiva di 5 km. La Barceloneta è la spiaggia della città, mentre la Nova Icària, nelle vicinanze del Porto Olimpico, è più piccola ma dispone di graziosi bar e ristoranti. Il lungomare della Platja del Bogatell è molto frequentato dai patiti del jogging, della bicicletta o dei pattini.

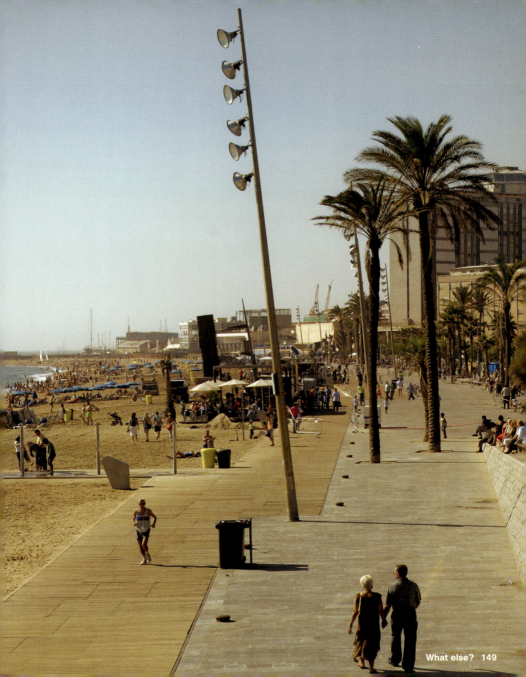

Useful Tips & Addresses

ARRIVAL IN BARCELONA

By Plane

Aeroport de Barcelona (BCN) – El Prat
Phone: +34 / 932 98 38 38
www.barcelona-airport.com
Barcelona's international main airport is located in El Prat de Llobregat, about 10 km (6 miles) southwest from the center of town. There are trains departing from the airport every 30 mins (line 10 from Spain's national railway operator Renfe) that are going to the railway station Sants which is also the end of the line (traveling time: 40 mins). There is also an airport bus called Aerobús A1 that departs every 15 mins with destination Plaça de Catalunya in the center of Barcelona. You will find information signs for the Aerobús at the airport. Taking a cab is another option. It takes 25 to 30 mins and costs approx. € 25.

Aeroport de Girona (GRO)
Phone: +34 / 972 18 67 08
www.girona-airport.net
The Girona airport, situated about 100 km (62 miles) northeast of Barcelona, is mainly frequented by low-budget airlines. Buses depart regularly from the terminal and will bring you to the Girona railway station (Estació de Girona). From there it is another 30 mins to Barcelona by express train which amounts to a total traveling time of 1 1/4 hours. It is also possible to go directly from the airport to the main bus station in Barcelona (Estació d'Autobusos Barcelona North) taking the Barcelona Bus (traveling time: 1 1/4 hours, single ticket € 11, Phone: +34 / 902 36 15 50). From the bus station it is just a 5–10 mins walk to the subway.

By Train

Estació Central de Sants
Plaça dels Països Catalans
The main railway station is very well connected with Barcelona's subway and bus networks. Unfortunately, there are construction works taking place at the Estació Central de Sants that will last at least until 2007. Two alternative railway stations named **Estació França**, situated on the outskirts of the old town, and **Sant Andreu Comtal** have to be used in the meantime.

Railway Information
Renfe, Phone: +34 / 902 24 02 02 (information and tickets), Phone: +34 / 902 24 34 02 (international information), www.renfe.es

Immigration and Customs Regulations
European citizens need a valid identity card for traveling to Spain. For EU citizens there are virtually no custom regulations. Every person at the age of 17 or older is allowed to carry goods for personal needs duty-free, e.g. 800 cigarettes, 400 small cigars, 200 cigars, 1 kg of tobacco, 10 l of liquor, 90 l of wine and 110 l of beer.

INFORMATION

Tourist Information

Spanish Tourist Office
www.tourspain.es
Turisme de Barcelona
www.barcelonaturisme.com
info@barcelonaturisme.com
Phone: +34 / 932 85 38 34
Phone: +34 / 932 85 38 33 (hotel reservation)
Fax: +34 / 932 85 38 31
Service Mon–Fri, 9 am to 8 pm

The Spanish **tourist information centers** offer abundant information materials, help finding suitable accommodation, organize city tours etc.:
Plaça de Catalunya 17-S, ground floor, daily 9 am to 9 pm
Plaça de Sant Jaume, Ciutat 2 (in the City Hall), Mon–Fri 9 am to 8 pm, Sat 10 am to 8 pm, Sun 10 am to 2 pm
Estació Central de Sants, in the central station, June–Sept daily 8 am to 8 pm, Oct–May Mon–Fri 8 am to 8 pm, Sat and Sun 8 am to 2 pm
Barcelona Airport, Terminal A and B, daily 9 am to 9 pm

Information Booths from Turisme de Barcelona:
Plaça d'Espanya, Corner Av. Reina María Cristina, July–Sept daily 10 am to 8 pm, Oct–June daily 10 am to 4 pm
Plaça de la Sagrada Família, July–Sept daily 10 am to 8 pm, Oct–June daily 10 am to 4 pm
Plaça del Portal de la Pau, at the Christopher Columbus monument, daily 9 am to 9 pm
Barceloneta, Passeig de Joan de Borbó, July–Sept 10 am to 8 pm

City Magazines

The small format program guide **Guía del Ocio** is published every Thu and informs its readers in Spanish about what's hot and what's not (available at newspaper stands and in tourist information centers). **The Metropolitan** is an event guide in English that is published once a month and can be found in movie theaters and bars. Information about fashion, design, architecture, bars, restaurants and nightlife in English and Spanish are offered by the quarterly **b-guided**.

Websites

General
www.barcelonaturisme.com – Official website of the city's tourist office offering hotel reservation, event calendar, information about sightseeing, public transportation, guided city tours etc. (in CA, ES, EN, FR)
www.bcn.es – Very informative web service provided by Barcelona's city administration (CA, ES, EN)
www.barcelona-tourist-guide.com – Up-to-date information service and interactive city map including photo guide. Among other things: accommodation service, city guides, transportation, restaurants, weather forecast (EN)

Going Out
www.atiza.com – Concerts, bars, discos
www.barceloca.com – Restaurants, bars, discos etc. including links and TMB transport information
www.guiadelocio.com/barcelona – Internet portal of the event guide Guía del Ocio offering tips for theater, concerts, movies, restaurants, bars, clubs (ES)

Art & Culture
www.bcn.es/icub – Information about cultural life in Barcelona including current programs for movie theaters and festivals (CA)
www.museupicasso.bcn.es – Website of the Picasso Museum (CA, ES, EN)
www.palaumusica.org – Opera and concert events in the Palau de la Música Catalana (CA, ES, EN)
www.tnc.es – Program of the Teatre Nacional de Catalunya (CA)

Useful Tips & Addresses

Sports & Leisure
www.basenautica.org – Sailing school and boat rental (CA)
www.circuitcat.com – Information and tickets for the F1 racetrack Circuit de Catalunya (CA, ES, EN, FR)
www.fcbarcelona.com – Website of the Barcelona-based soccer team Barça (CA, ES, EN)

Accomodation
www.barcelonaturisme.com – Online booking center of the city's tourist office (CA, ES, EN, FR)
www.oh-barcelona.com – Wide selection of apartments as well as single rooms in host families and flat-sharing communities (EN)
www.citysiesta.com – Short-term accommodation, private rooms and apartments (EN)

Event Calendar
www.guiadelocio.com/barcelona – Online version of the popular city guide (ES)
www.lecool.com – Online calendar informing about exhibitions, concerts, cinema and the music scene; updated once a week (ES, EN)
www.agendabcn.com – Concerts, theater, sport events etc. (CA, ES)

RECOMMENDED LITERATURE

Eduardo Mendoza
The City of Marvels. This is the story of a boy that comes from a Spanish rural area and makes his way to the top becoming the mightiest man in Barcelona.

Colm Tóibín
Homage to Barcelona. A city guide with a literature like feel to it.

Manuel Vázquez Montalbán
An Olympic Death. Detective story set in Barcelona right before the Olympic Games in 1992. One of the most brilliant and thrilling novels about the grumpy private detective Pepe Carvalho.

Carlos Ruiz Zafón
The Shadow of the Wind. Daniel Sempere grows up in the grey world of the post-civil war under the dictatorship of Franco. A mysterious book leads him into a labyrinth of adventurously interconnected life stories. This book has been in the Spanish bestseller lists for three years.

CITY TOURS

Sightseeing Tours by Bus

Bus Turístic
Open double-decker buses circulate on three different routes in the city. Starting at 9 am they depart every 5 mins during summer and every 25 mins during winter from Plaça de Catalunya, with possibility to hop on/hop off on one of the 42 stops. Tickets can be purchased in the bus or at Turisme de Barcelona; a day ticket is € 18, a two-day ticket is € 22.

Barcelona by Night
Julià Travel and Pullmantur Bustour will take you on a trip through Barcelona by night which includes going to a Tapas bar and a Flamenco show, Thu–Sat, 7.30 pm to approx. 12.30 am; approx. € 90/pers.
Julià Travel, Ronda Universitat, 5
Phone: +34 / 933 17 64 54
www.juliatravel.com
Pullmantur, Gran Via, 645
Phone: +34 / 933 18 02 41
www.pullmantur-spain.com

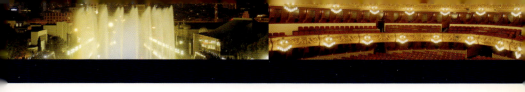

Boat Tours

Golondrinas
Offered tours are: harbor tour, from the harbor through Port Vell to the modern industry harbor as well as from the harbor to the Port Olímpic. The piers are located at the Portal de la Pau near the Christopher Columbus monument at the end of the Rambles. April–June Mon–Sat 11 am to 6 pm, Sun 11.45 am to 7 pm, July–Sept daily 11.45 am to 7.30 pm, Oct–March Mon–Fri 11.45 am to 4 pm, Sun 11.45 am to 6 pm; duration: 30 mins – 1 1/2 hour; from € 4/pers.; www.lasgolondrinas.com.

Guided City Tours

Private City Guides
Barcelona Guide Bureau
Via Laietana 54, Phone: +34 / 933 10 77 78
www.bgb.es
4 hours, € 150–179 (more expensive on Sat/Sun)

Thematic Tours
Starting from the Plaça de Catalunya, Turisme de Barcelona offers four different walking tours to the most important sights of the city all over the year:
Barri Gòtic, Mon–Sun 10 am (EN), Sat 12 am (CA, ES), duration: 90 mins, € 9/pers.;
Picasso, Tue–Sun 10.30 am (EN), Sa 11.30 am (CA, ES), duration 90 mins, € 11/pers. (including entrance for the Picasso Museum);
Modernisme, Fri and Sat 4 pm (EN), Sat 4 pm (CA, ES), June–Sept starting at 6 pm, duration 2 hours, € 9/pers.;
Gourmet, Fri and Sat 11 am (EN), Sat 11 am (CA, ES), duration 2 hours, € 11/pers.

Ruta del Modernisme
The **Centre de Modernisme** offers a walking tour from the Palau Güell to the Catalan Art Nouveau buildings which costs € 7.50/pers. Within 30 days the ticket grants a 50% entrance discount at the following places: Palau Güell, Palau de la Música Catalana, La Pedrera, Sagrada Família, Fundació Tàpies, Museu Gaudí and Museu d'Art Modern. Information: Centre de Modernisme, Passeig de Gràcia, 4, Phone: +34 / 934 88 01 39.

Lookouts

El Corte Inglés
Plaça de Catalunya
From the cafeteria in the upper floor of this department store you have a wonderful view over the Eixample district, Mon–Sat 10 am to 10 pm.

Mirador de Colom
Plaça del Portal de la Pau
The viewing platform (60 m / 200 ft high) of the Christopher Columbus monument offers a fantastic view over the harbor, the Rambles and the old city. Elevator costs 2 €/pers.

Montjuïc
Using the cable car Transbordador Aeri you can go from the Torre de Sant Sebastià in Barceloneta to the lookout at the Plaça de l'Armada on Barcelona's trademark mountain Montjuïc. From there you have an incredible view over the harbor and the city center. Cable car March to Oct 10.30 am to 7/8 pm, Nov–Feb noon to 5.30 pm, every 15 mins; one-way tickets cost € 7.50.

Useful Tips & Addresses

Sagrada Família
www.sagradafamilia.org
The elevator takes you to the spires of the cathedral (55 m / 180 ft and 65 m / 210 ft high). April–Sept 9 am to 8 pm, Oct–March 9 am to 6 pm; € 2/pers.

Torre de Collserola
Carretera de Vallvidrera al Tibidabo
www.torredecollserola.com
The radio tower on the Tibidabo is 288 m / 945 ft high and has a glazed lookout platform in 115 m / 377 ft height. Wed–Sun 11 am to 2.30 pm, 3.30 pm to 7 pm; € 5.20/pers.

TICKETS AND DISCOUNTS

Ticket Offices

Servi-Caixa
Phone: +34 / 902 33 22 11
www.servicaixa.com
Servi-Caixa sells tickets for cultural as well as for sport events. The tickets can be purchased at the cash machines in La Caixa banks.

Institut de Cultura de Barcelona
Rambles 99, in the Palau de la Virreina Phone: +34 / 933 01 77 75

Discounts

Barcelona Card
This card offers free transportation with bus and subway as well as reduced fares for the Aerobús from/to the airport, free entrance in twelve selected museums and entrance discounts of 10–50% in other museums, theatres, leisure facilities, restaurants, nightclubs and shops. It is available at the city's tourist information centers or online at www.barcelonaturisme.com. The card is valid for 2, 3, 4 or 5 days and its price depends on duration of validity (€ 24–36/pers.).

Articket
Free entrance in seven big museums (Museu Nacional d'Art de Catalunya, Museu d'Art Contemporani de Barcelona, Fundació Joan Miró, Fundació Antoni Tàpies, Centre de Cultura Contemporània de Barcelona, Museu Picasso, Fundació Caixa Catalunya). This ticket is available at the tourist information center Plaça de Catalunya and Plaça Sant Jaume or online at www.barcelonaturisme.com. It costs € 20/pers. and is valid for six months. www.articketbcn.org

GETTING AROUND IN BARCELONA

Local Public Transport

Transports Metropolitans de Barcelona (TMB)
www.tmb.net (CA, ES, EN)
On its website, TMB offers subway and bus maps as pdf downloads and interactive line maps.

Metro, High-Speed Railway (FGC) and Bus
There are six **metro lines (subway)** and **FGC high-speed railway lines** for public transportation connecting all parts of the city. They circulate Sun–Thu 5 am to midnight, Fri, Sat and before holidays 5 pm to 2 am. The municipal **buses** circulate between 5 am and 11 pm and a night bus called Nitbús offers transportation services on the main routes from 11 pm to 5 am. The Tibibús circulates between the Plaça de Catalunya and the Tibidabo amusement park stopping also at the Park Güell. The bus only circulates during the opening hours of the park. The spacious

Tombbús circulates through the shopping areas of Barcelona from the Plaça de Catalunya, down the Rambles and the Passeig de Gràcia to the Plaça Pius XII.

Tickets are available at the vending counters and machines in the subway stations as well as from Turisme de Barcelona, the TMB customer service center at the Plaça Universitat, at the Sagrada Família and in the Estació Central de Sants. Bus tickets can be purchased directly from the bus driver. Single tickets with subway or bus start at € 1.20, a ticket for 10 journeys is € 6.65, a day ticket costs € 5, a two-day ticket costs € 9.20 and a three-day ticket is € 13.20.

Tramvia Blau
The nostalgic streetcar connects Plaça de Kennedy with the bottom lift station of the Tibidabo cable car. During summer, the streetcar departs every 30 mins and a one-way ticket costs € 2.20.

Cog Railway and Cable Cars
The **Funicular de Montjuïc** starts from the Plaça Raquel Meller/Paral·lel subway station to the Av. de Miramar / Plaça Dante on the Montjuïc (in summer from 9 am to 10 pm, in winter to 8 pm). The cable cars of the **Transbordador Aéreo** start from the Torre de Sant Sebastià in Barceloneta and go up to the Montjuïc. There is a stop at the Torre de Jaume I (March–Oct 10.30 am to 7/8 pm, Nov–Feb noon to 5.30 pm, every 15 mins; one-way ticket € 7.50). The cable railway **Telefèric de Montjuïc** is not circulating at the moment because it is being renovated.
The **Funicular del Tibidabo** connects the Plaça Dr. Andreu with the Plaça de Tibidabo (Mid of June–July Thu, Fri 10 am to 17 pm, Sat and Sun to 8 pm, July–Sept daily to 9 pm, Oct–May only during the weekends 10 am to 7 pm, every 30 mins, only circulates during the opening hours of the Tibidabo amusement park; one-way ticket € 2).

Cabs

Fono Taxi, Phone: +34 / 933 00 11 00
Barna Taxi, Phone: +34 / 933 57 77 55 and +34 / 933 00 23 14
Taxi Groc, Phone: +34 / 933 22 22 22
www.taxibarcelona.com
Taking a taxi in Barcelona is moderately cheap. Taxis in Barcelona are traditionally black and yellow but there is an increasing number of white taxis on the streets of Barcelona lately. A green light on the top of the taxi indicates that it is free and can be stopped by waving the hand.

Cycle Rickshaw and Bicycle Rental

Trixi
www.trixi.com
Cycle rickshaws circulate between 11 am and 8 pm. Prices: € 6/15 mins, € 10/30 mins and € 18/60 mins

Bicycle Rental
Barcelona Bici, Phone: +34 / 932 85 38 32
Al punt de trobada, Badajoz, 24
Phone: +34 / 932 25 05 85
Mon–Fri 9 am to 2 pm and 4 pm to 8 pm, Sat 9 am to 2pm, Sun 4 pm to 8 pm
Biciclot, Passeig Marítim, 33
Phone: +34 / 932 21 97 78
www.biciclot.net

Useful Tips & Addresses

FESTIVALS & EVENTS

Calvacada de Reis (Coming of the Three Kings)
5th Jan; procession from the Christopher Columbus monument to the cathedral

Carrera Ciudad de Barcelona
March; Marathon (www.theproject.es)

Festival de Guitarra
Mid of March–May; series of concerts with flamenco, jazz and classical music events

Semana Santa
Eastern; religious feasts in the Holy Week including procession on Good Friday

Dia de Sant Jordi
On St George's Day, 23rd April, it is traditional to give a rose and a book to a loved one. Sales booths are installed at the Plaça Sant Jaume and other places.

Primavera del Disseny/Fotográfica
Mid of April–mid of June; international biennales for design (in uneven years) and photography (in even years)

Sónar
Mid of June; It is a three-day festival for sound art, techno music, net art and multimedia. (www.sonar.es)

Nit de Sant Joan
23rd/24th June; street festival including dance and fireworks to celebrate Midsummer

Festival El Grec
July/Aug; Open air theater and music events mainly in the amphitheater Grec on the Montjuïc

Festa Major de Gràcia
Middle of Aug; big summer festival of the city district Gràcia that lasts ten days

La Diada
11th Sept; Catalan national holiday

Festes de la Mercè
24th Sept; Festival in honor of the city's patron saint Santa Mercedes with music, acrobatics and fireworks

Festival Internacional de Jazz de Barcelona
Oct/Nov; international jazz festival lasting several weeks (Phone: +34 / 934 81 70 40, www.theproject.es)

USEFUL NOTES

Money
National currency: Euro (€)
Bank and credit cards: You can get cash with any Maestro or credit card at one of the multiple cash machines (cajero automático). These cards are also accepted in almost all hotels, restaurants and stores.

Emergency
Police/Emergency Call: Phone: 091 or 112
Fire Department: Phone: 061
Ambulance: Phone: 080
Dentist: Phone: +34 / 934 15 99 22
Pharmacy: Phone: 010 or 098
Police (in case of theft and accidents): Turismo Atención, Guardia Urbana de Ciutat Vella, La Rambla, 43, Phone: +34 / 933 44 13 00

Opening Hours
Banks: Mon–Fri, 8.30/9 am to 2 pm, in winter also on Sat 8.30/9 am to 1 pm.
Shops: Mon–Fri 9/9.30 am to 1.30 pm and

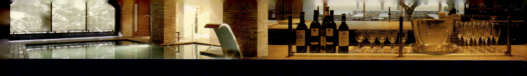

4.30/5 pm to 8/8.30 pm, Sat 9/9.30 am to 2 pm. Department stores and shopping centers do not close during midday, Mon–Sat until 9/10 pm. Smaller shops also open on holidays and/or on Sun mornings.
Museums: Often closed on Sun afternoon and Mon
Restaurants: Noon to 3 pm and 9 pm to 12 pm. Usually closed on Sun

Costs & Money
In comparison with other major cities, the prices are rather moderate in Barcelona. Nevertheless, you can find expensive shops and hotels all over town. Economic accommodations are to be found in youth hostels, pensions and hostels. Prices for hotels only include the actual overnight stay and not the breakfast. A double room costs € 30–70 per night in low-budget hotel and from € 180 upward in luxury hotels.

Smoking
Since 2006, smoking is prohibited in public buildings, hotels, railway stations, airports and shopping centers as well as in public transportation in all of Spain. It is also prohibited to smoke in bars and restaurants. Bigger restaurants, however, often provide a smoking area.

When to go
There is a mild and balanced climate in Barcelona all over the year. The most enjoyable travel season is from May to June and from Sept to Oct. During July and Aug the heat can become unbearable but taking a bath in the sea is the ideal refreshment. During these months you can stay up very long and enjoy the nights sitting on the street terraces or going to festivals. The city is generally less crowded during the summer and the majority of the restaurants, museums and stores are not opened as long as usual or are completely closed. The winter is rather cool and rainy but temperatures rarely go below freezing. Going to museums or exhibitions is the suitable activity for this time of the year.

Safety
The crime rate in Barcelona is not higher than in other European major cities and common precaution measure should suffice. Thieves are active on the Rambles, in the Barri Gòtic, on the beach and in restaurants and bars. During the night it is not recommendable wandering alone through the Barri Xinés close to the harbor.

Telephone
Area Code for Barcelona: The former city code has become part of the regular nine-digit phone number in Spain and always needs to be dialed regardless from where you call.
Calling from abroad: +34 + desired phone number without 0
Calling from Barcelona: country code + area code without 0 + desired phone number
Directory Assistance: Phone: 11 822 and www.qdq.com

Public pay phones work with coins or telephone cards (tarjetas telefónicas) that can be bought in tobacco shops. Newer pay phones also accept credit cards.

Tipping
It is normal to pay a tip of about 5–10 % of the actual invoice amount in Spain. Normally you leave the tip on the table when leaving the restaurant. Also cab drivers and hotel employees are happy about an appropriate tip.

No.	Object	Page
1	Agua	64
2	Anella Olímpica (Olympic Ring)	36
3	L'Aquàrium de Barcelona	140
4	Axel Hotel Barcelona	126
5	Banys Orientals	116
6	Bestial	66
7	Boadas Cocktail Bar	68
8	Caelum	96
9	Café de L'Acadèmia	70
10	Café Schilling	72
11	Carpe Diem Lounge Club & Restaurant	74
12	Casa Batlló	24
13	Casa Calvet	88
14	Casa Camper Barcelona	118
15	Casa del Llibre	106
16	Casa Milà (La Pedrera)	26
17	CheeseMe	76
18	Comerç 24	78
19	Cuines Santa Caterina	80
20	Els Quatre Gats	82
21	Fundació Antoni Tàpies	54
22	Fundació Joan Miró	56
23	Gran Hotel La Florida	136
24	Gran Teatre del Liceu	44
25	Granados 83	128
26	H1898	120
27	Harbor Tour in the Golondrinas	142
28	Hotel Arts Barcelona	114
29	Hotel Omm	132
30	Iguapop Shop	100
31	Jardí Botànic de Barcelona	144
32	Les Rambles	22
33	Market Hotel	130
34	Mercat de la Boqueria	102
35	Monestir de Pedralbes	34
36	Municipal Beaches: Platja de la Barceloneta (36a) Platja Nova Icària (36b) Platja del Bogatell (36c)	148
37	Museu d'Art Contemporani – MACBA	46
38	Museu Marítim	48
39	Museu Nacional d'Art de Catalunya – MNAC	58
40	Museu Picasso	50
41	Neri Hotel & Restaurante	124
42	Ot	92
43	Palau de la Generalitat	18
44	Palau de la Música Catalana	52
45	Park Güell	32
46	Passeig de Gràcia	108
47	Pavelló Mies van der Rohe	60
48	Plaça Reial	20
49	Port Olímpic	40
50	Pulitzer	134
51	Rita Blue	84
52	Sagrada Família	28
53	Taktika Berri	90
54	Torre Agbar	38
55	Torre D'Alta Mar	86
56	Transbordador Aeri del Port Access Torre de Sant Sebastià (56a) Access Torre de Jaume I (56b) Access Zona Miramar (56c)	146
57	Vila Viniteca	104
58	Vinçon	110
59	Xocoa	98

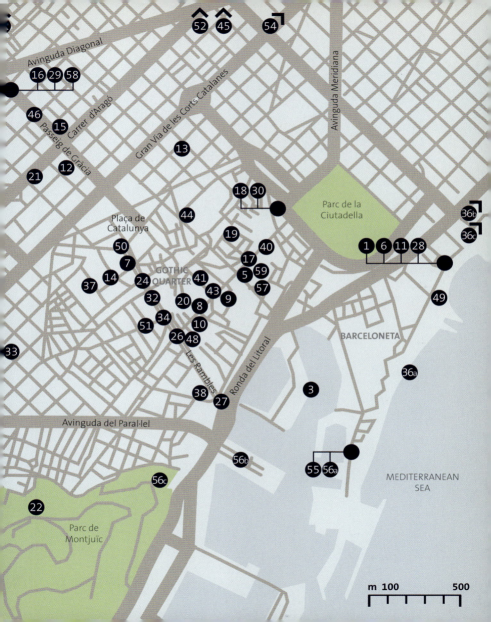

City Highlights INTERNATIONAL EDITION

BARCELONA
ISBN 978-3-8327-9192-6

LONDON
ISBN 978-3-8327-9194-0

NEW YORK
ISBN 978-3-8327-9193-3

PARIS
ISBN 978-3-8327-9195-7

Size: 15 x 19 cm / 6 x 7 ½ in.
160 pp., Flexicover
c. 300 color photographs
Text in English, French, Spanish and Italian
€ 14.90 $ 18.95 £ 9.95 Can.$ 25.95 SFR 27.50

teNeues